Credit Scores, Credit Cards

How Consumer Finance Works:
How to Avoid Mistakes and
How to Manage Your Accounts Well

SILVER LAKE PUBLISHING
LOS ANGELES, CA ♦ ABERDEEN, WA

Credit Scores, Credit Cards

How Consumer Finance Works: How to Avoid Mistakes and How to Manage Your Accounts Well

First edition, 2005
Copyright © 2005 by Silver Lake Publishing

Silver Lake Publishing
111 East Wishkah Street
Aberdeen, WA 98520

For a list of other publications or for more information from Silver Lake Publishing, please call 1.360.532.5758. Find our Web site at **www.silverlakepub.com**.

Library of Congress Catalogue Number: Pending

The Silver Lake Editors
Credit Scores, Credit Cards
Includes index.
Pages: 288

ISBN: 1-56343-782-1

ACKNOWLEDGMENTS

The Silver Lake Editors who have contributed to this book are Sander Alvarez, Esq., Sue Elliot-Sink, Kristin Loberg and James Walsh.

This is the 16th title in Silver Lake Publishing's series of books dealing with risk and economic issues that face people living in the United States and other developed countries.

In this book, we refer to contract terms and legal decisions from the United States—but the spirit of the discussion about consumer credit can apply beyond the jurisdiction of the courts cited.

This book is intended to make the theories and practices of consumer lending understandable. The Silver Lake Editors welcome feedback. Please call us at 1.360.532.5758 during regular business hours, Pacific time. Fax us at 1.360.532.5728. Or e-mail us at **TheEditors@silverlakepub.com**.

James Walsh, Publisher

ACKNOWLEDGMENTS

CONTENTS

CHAPTER 1

WHY CREDIT IS
SO IMPORTANT

You've found your dream house. The neighborhood is perfect. The schools are great. The kitchen has everything you want.

You've negotiated a good price. You've signed reams of paperwork. And you open an escrow account.

Then your mortgage broker calls. Remember the great interest rate she quoted you last week? You don't qualify for it. She says there are some problems with your *FICO score*. Your interest rate is going to be higher by almost four percentage points.

> **Suddenly, your monthly payments on a $200,000 loan jump from $1,150 to $1,620. That's a 40 percent increase!**

Your eyes well up with tears as that dream house slips away—along with the nonrefundable deposit check you'd written. And it's all because the mortgage lenders said **your credit score** was low.

Buying a house is the single biggest purchase most consumers will ever make—and the vast majority of people buy that house on credit. But home buying **isn't the only time** your credit is important.

Your credit is a factor when you want to rent an apartment, buy a car, get braces for your children or take advantage of a "no interest for six months" offer on a big-screen TV. Sometimes, your credit history will even come into play when you apply for **insurance** or for **a job**.

Credit history plays a vital role in your day-to-day life, making expenses like a home mortgage more—or less—expensive for you. And it's practically impossible to rent a car without a credit card.

IT'S A CREDIT ECONOMY

A growing number of people purchase products and services on credit—either with credit cards or by taking out other types of consumer loans. Americans borrow to buy cars and trucks and put less money down when they buy homes, as home prices escalate in many parts of the country.

But credit cards are **the fastest growing form of consumer borrowing** in the developed world. And they have the biggest impact on most consumers' financial status.

Credit cards are used on a regular basis by more than 73 percent of American households, up from 16 percent in the 1970s. Most Americans have at least one general-purpose credit card these days, and

more often they have two or three. By *general-purpose*, we mean a credit card not issued by a specific store or retail chain; these cards include Visa, MasterCard, Discover or American Express cards that can be used almost anywhere.

> **In 1999, American consumers charged about $1.2 trillion on their general-purpose credit cards. By 2003, that number had grown by about a third—to more than $1.5 trillion.**

Specifically, American Express saw a 13 percent increase in cardholder spending from 2003 to 2002. And that business was increasingly profitable. According to the company, American Express Bank (AEB) reported net income for 2003 of $102 million, up 27 percent from $80 million the year prior.

Visa, the largest player in the general-purpose credit card market, generated around $3 trillion in card sales volume worldwide **each year** in the early 2000s. Even Diners Club, a relatively small player in the market, racked up gross sales volume of $31 billion in 2001.

And then there are so-called "captive cards"—credit cards issued by department stores, gas stations and specialty retailers. They account for something like **half again** the amount charged to the general-purpose cousins.

In theory, credit cards allow you to enjoy your purchases for as long as a month before you have to pay

a dime—and it's all interest-free. Or at least it *would be* interest-free, if people **paid off their credit card balances** in full each month. Most don't.

According to Fair, Isaac & Co., which tracks consumers' credit histories, about 10 percent of Americans have credit card balances that exceed $10,000. On the other hand, nearly half of the population is much more conservative, carrying a balance of less than $1,000. (You'll read a lot about Fair, Isaac & Co.—called by the acronym "FICO" by people in the credit and banking industries—through the course of this book.)

Those balances generate a lot interest—money owed to the card companies by the card users. In some cases, the interest rates are as high as 23 percent. (However, the industry group Your Credit Card Companies notes that the average credit card interest rate was approximately 12.75 percent in 2003.)

Of course, credit cards aren't the only kind of credit consumers use. According to FICO, the average consumer today has 11 credit "obligations." Of those, seven are likely to be credit cards; the other four are likely to be **installment loans**—including auto, home and student loans.

If you add it all up, you find that 30 percent of Americans carry more than $10,000 of **non-mortgage-related consumer debt**. And credit cards are the biggest slice of that debt pie.

The good news: Most people pay their bills on time. FICO notes that fewer than 40 percent of consumers have ever been reported as 30 or more days late on a payment, and only 20 percent have ever been 60 or more days past due.

CREDIT KEEPS GETTING EASIER

Consumer credit is a sort of **self-fulfilling prophecy**. As more consumers use it, more merchants need to accept it. And, as more merchants accept it, more consumers use it.

That's why it seems as if everybody wants to offer you credit these days. If you shop at a department store and you pay with cash or by check, many employees have been **trained to ask** you to open up one of the store's own charge accounts.

> **Even relatively small businesses can offer a private-label credit card to their customers. That's because credit card companies offer specialized programs through a variety of trade associations.**

For instance, members of SEMA (the Specialty Equipment Market Association) are all eligible to participate in CarCareONE, a private-label credit-card program from GE Retail Sales Finance. So, manufacturers, distributors, retailers and installers can offer their customers instant, on-the-spot credit, as well as 90-day "same-as-cash financing."

Why do they? According to SEMA, "Many companies find that consumers with CarCareONE credit cards will **make larger purchases** and are more loyal than customers without the card."

As the name suggests, CarCareONE credit cards are automobile-focused. But private-label programs extend far beyond the automotive world. Citi Commerce Services (CCS) helps all kinds of businesses develop customized retail credit card program. In fact, CCS has made it possible for retailers in a wide range of industries to offer a **store-specific credit card**. These industries include:

- travel;
- jewelry;
- apparel;
- catalog sales;
- furniture;
- automotive;
- office products;
- home improvement;
- consumer electronics; and
- computers.

These are the credit programs for merchants. On the consumer side, credit card companies market their products even more aggressively. The best example of this: So-called **"affinity" cards**. These are general-purpose credit cards that are associated with a particular airline or auto maker or membership group. These cards—usually Visa or

MasterCard, but with that fact downplayed—generate benefits based on how many dollars the holder spends. The benefits are specific to the group; such as frequent flier miles with an airline card, contributions with a political affinity card or discounts on car purchases with an auto maker card.

> There are the affinity cards that you can sign up for in order to get zero interest for several months on a major purchase—such as the Visa cards offered by Circuit City and other consumer electronics retailers in order to get you to spring for that $3,000 home entertainment system.

There are traps and fine-print conditions to all of these benefits, as we'll see later. But the fact remains that credit cards are a booming part of the economy.

A CREEPING EFFECT

Credit has a steady, **cumulative effect** on the way people buy things. The car industry is a good example of this creeping influence.

Through the 1960s, most Americans paid cash for their automobiles. If a person borrowed to buy a car, he or she would usually make a large downpayment (often half the purchase price) and take a one- or two-year secured loan through a local bank.

In the 1970s, auto makers decided to finance the purchase of their products in a systematic way. They

marketed two- and three-year loans which required smaller down payments.

In the 1980s, car companies started leasing cars—which essentially **eliminated the down payment** and the whole idea of a car as a thing that someone would buy and keep for many years. It also made luxury cars more affordable to most consumers. At first, leases had two- to three-year terms. Traditional loans lengthened their standard terms to four or five years to compete.

By the early 2000s, most Americans financed most of their new car purchases. Gone were the days of 24-month auto loans; five-year loans or leases had become standard—and six-year loans were increasingly common.

So-called **"luxury" vehicles**—which included some trucks—had grown from less than 10 percent of the car market to more than 30 percent.

> This is the cumulative effect of consumer debt: Higher prices and levels of luxury and less outright ownership. Some consumer advocates criticize this process as making a permanent debtor class; but others defend it as bringing the life-style of the wealthy to a mass market.

Whatever the sociological concerns, there's no doubt that **a credit economy** requires an ordinary citizen to pay more attention to his or her ability to get credit.

STUDENT LOAN DEBT

Like the automobile industry, the university education industry has used credit to create new customers and sell them **more expensive product.**

> **With university tuition costs rising faster than other prices, many students are encouraged to borrow money through any of several government-sponsored loan programs. As a result, they graduate with incredible debt loads.**

For example, in 2004, the annual tuition at the University of California, Los Angeles (UCLA) was $6,585.52 for a California resident and $23,541.52 for a nonresident. That didn't take into account housing, books, meals or any other living expenses.

According to the University of Notre Dame, the average 2004-05 expense budget for an undergraduate student included:

Tuition and Fees	$29,510
Room and Board	7,590
Books and Supplies	850
Personal Expenses	900
Transportation	500
Total	$39,350

According to the American Council on Education:

> *More students are borrowing to pay for their college education, up from 49 percent in 1993 to 65 percent in 2000. Students also borrowed more. In 1992-93, the median amount borrowed was just over $9,500. In 1999-2000, that amount jumped to $16,500.*

While the Council's studies showed that most students who graduated in the class of 2000 have a debt burden equal to seven percent of their income, the Council warned, "**Debt burden** is a growing concern for a subset of students with larger than average debt or lower than average earnings."

Furthermore, "Debt burden will increase if borrowing levels continue to rise, interest rates climb or recent graduate salaries decline."

INCREASING MORTGAGE DEBT

While all consumer credit-based spending has been rising, the jump in home mortgage debt worries economists most.

From 2001 to 2004, home mortgage debt increased 25 percent (after adjusting for inflation), according to the Senate's Joint Economic Committee (JEC).

The JEC noted:

> *Analysts have expressed concern about the growth of consumer debt and its effect on the U.S. economy.*

Some fear that the combination of increasing debt and higher interest rates will impair the ability of households to meet their monthly financial obligations. However, interest payments as a percentage of disposable income have actually fallen since the end of the recession in 2001. Total household debt has increased since the end of the recession, but the vast majority of the increase can be attributed to the growth of home mortgage debt spurred by historically low mortgage interest rates.

...Mortgage debt has grown from 32 percent of gross domestic product (GDP) in 1980 to over 60 percent today. This increase is reflected in part in the record-high home ownership rate in the U.S. Consumer credit {including credit cards and auto loans} grew more slowly, increasing from 13 percent of GDP in 1980 to 18 percent.

THE BOTTOM LINE

Heavy consumer borrowing is a reality for many Americans. So, it's more important than ever for every consumer to be smart about his or her credit habits and ability to borrow. And the main way that lenders measure this ability: **credit scores**.

Credit scores are the results of programs that lenders use, based on information that other lenders report to central information clearinghouses, to make decisions about how you're likely to pay.

Credit scoring systems award people points for having credit, using it and making payments on time. **The more points you have, the better your credit**. Every time you use a credit card and pay the balance on time, your score goes up; every time you go over your credit limit and pay late, your score goes down.

Other financial or legal factors also are counted. Having over $100,000 in cash in the bank raises your score; declaring bankruptcy lowers it. A lot.

In the U.S., most lenders use some version of the scoring system developed by Fair, Isaac & Co. A person's "FICO score" ranges from 400 to over 800 points. The range works something like this:

- A score of 420 means you can't get a credit card, car loan or home mortgage.

- A score of 570 means you can get any of these—but you won't get the best, advertised interest rate. And you'll probably have to pay extra fees.

- A score of 720 means you'll get the best interest rates and the fewest fees.

Credit scores are fluid things. They can change as quickly as monthly...though they usually change on **a quarterly basis**.

Smaller changes usually occur more slowly; bigger changes—if you declare bankruptcy or win the lottery—occur more quickly.

> Your credit score is probably the most important aspect of your life that isn't managed by the government. It's controlled by a loose affiliation of banks, credit card companies, other kinds of lenders and the credit bureaus that track all of the information.

If you're like most Americans, you have only a vague idea of where you stand, in terms of your credit score. Many people pay closer attention to their mortgage interest rates or the deal they got on their car. There's **something unpleasant** about checking the details of your credit score—even if, in truth, it's not so bad.

Likewise, many Americans are conditioned to look at **certain aspects** of a credit deal but ignore others. Did you sign up for a special low-interest promotional card offer without reading any of the fine print? In some cases, any purchases beyond the initial promotional offer may incur shockingly high interest rates.

> Electronics stores often play a variation on that scheme. They will offer a captive card with a low interest rate—sometimes a zero-interest rate. But the special deal is only good for the *first purchase* on the card. Everything else comes with a rate of 17 or 20 percent.

Do you know what will happen if you miss a payment or two on any of your credit cards? What about your auto loans? Home loans? In many cases, the **interest rates will shoot up**.

CONCLUSION

We're not trying to give you guilt. We're simply pointing out the places where you may be able to save substantial money, simply by paying attention to a few "little details."

One way you can save serious money is by **improving your credit score**, since it's directly related to how much you pay for credit. For instance, people with great credit scores (above 700) can pay tens of thousands of dollars less, over the life of a 30-year mortgage, than people with just okay credit scores.

And they can be related to other seemingly unrelated things, too, like your ability to get a job or even get insurance. That's right. Insurance companies and even potential employers may check out your credit history to try and determine your level of personal stability.

Whether you have good credit or lousy credit, the first step is to **find out what your credit score is**. Then take the steps we recommend in this book to improve that score. Your wallet will feel the difference. So will you.

2

THE MECHANICS OF CREDIT SCORES

Credit scoring has played a prominent role in making consumer credit **accessible to the not-so-rich**. In the U.S., most credit scoring systems rank everyone on a scale from 400 to 850 points. Where you are on the scale can affect a lot about your life.

According to Your Credit Card Companies, a lobbying group of financial services companies that includes the card issuers MasterCard, Discover and Capital One:

> *{Between the early 1970s and early 2000s}, access to credit cards has increased 36 percent for lower-income families and 65 percent for middle-income families. The percentage of minority families with credit cards has more than doubled, from 25 percent in 1983 to 54 percent in 2001.*

But exactly how do rigid credit scores lead to a **more democratic credit** system? The answer has to do with two concepts: *Risk* and *trust*.

Credit scores help lenders make decisions about what people are risks...and which people they will trust

with loans. **Consulting companies** like Fair, Isaac & Co. help lenders make credit scoring decisions based on information held—and constantly up-dated—by **credit bureaus**.

Throughout this book we refer to the "big three" U.S. credit bureaus—Equifax, Experian and TransUnion. These companies control the U.S. consumer credit scoring industry. Their importance to the financial services industry...and your ability to borrow money...is large and growing.

Like most smaller credit bureaus, the big three keep files that include **personal information** like Social Security numbers and account information of individual consumers.

But their clients are not the people whose information they keep; their clients are the **banks and consumer finance companies** who decide whether—and on what terms—to lend money to those individuals.

The Fair Credit Reporting Act (FCRA) is an attempt by the U.S. government to **restore some balance and accountability** to the credit rating industry. According to the Federal Trade Commission (FTC):

> *The FCRA is designed to promote accuracy, fairness and privacy of information in the files of every "consumer reporting agency" (CRA). Most CRAs are credit bureaus that gather and sell information about you—such as if you pay your*

bills on time or have filed bankruptcy—to creditors, employers, landlords and other businesses.

You must be told if information in your file has been used against you. Anyone who uses information from a CRA to take action against you—such as denying an application for credit, insurance or employment—must tell you, and give you the name, address and phone number of the CRA that provided the consumer report.

You can find out what is in your file. At your request, a CRA must give you the information in your file, and a list of everyone who has requested it recently. There is no charge for the report if a person has taken action against you because of information supplied by the CRA, if you request the report within 60 days of receiving notice of the action. You also are entitled to **one free report** every 12 months upon request if you certify that:

1) you are unemployed and plan to seek employment within 60 days;

2) you are on welfare; or

3) your report is inaccurate due to ID theft or other fraud.

Otherwise, a CRA can charge you for a copy of your credit report (though that's changing).

Access to your file is limited. A CRA may provide information about you only to people with a need recognized by the FCRA—usually to consider an application with a creditor, insurer, employer, landlord or other business.

HISTORY OF CREDIT SCORING

How did all of this get started? In the very early days, when people bought things on credit at the general store, the store clerk wrote the purchase amount on a piece of paper that was then put into a "cuff." A cuff was a paper tube that merchants wore on their wrists. (This is also the origin of the term "buying on the arm"—another way to say buying on credit.)

When a merchant offered too much credit or credit to the wrong person, he or she would lose money and have financial problems. Some would go out of business. Eventually, local merchant groups started collecting all of the information from these clerks' cuffs and putting it together for other merchants to check before granting credit.

These systems were known as **mutual protection societies** or **business roundtables**; and sometimes **chambers of commerce** served the same role.

> Whatever name it took, the local group's scope was limited geographically, by town or county. And the data it collected was not consistent; it might included character references, employment information, insurance information or more detailed bank account information. In some cases, the information sharing even violated legal privacy protections.

While they were better than nothing, these infor-mal local groups proved to be an inefficient way for

businesses to protect themselves from bad debt. There was no verification that the information was correct; and local biases, favoritism and politics could make for unreliable reports—either **too bad about good risks** or **too good about bad ones**.

Plus, the people about whom information was being shared had no way of checking the reports. The only groups that could access the information were lenders and merchants. A merchant who didn't like someone could cause that someone a lot of trouble.

The first independent, third-party consumer reporting agencies in the U.S. were established in the mid-1800s; several were national in scope, operating much like a modern-day franchise system. They were set up as a network of offices across the country.

Credit agencies differed from mutual protection societies in that they allowed **anyone to access the credit information**—for a price. Local branches paid a percentage of their profits to their central office in exchange for credit information from other locations. These outfits were the corporate ancestors of modern day companies like American Express, Western Union and Wells Fargo Bank.

Technology developments in the late 1800s, including the typewriter and carbon paper, led to even greater efficiencies for independent credit agencies. Their accumulated information was more widely available, more accurate and covered a much larger geographical area.

These new credit bureaus had to deal effectively with various groups: their **subscribers**, the **people and businesses** about whom they reported, their branch office **correspondents** and the **general public**.

But, generally, these early credit agencies served a small part of the U.S. population. Through the early 1900s, most Americans stayed close to home and didn't need credit companies to vouch for them in unfamiliar places.

World War II changed all of that. So many people travelled from coast to coast—and to Europe or Asia—in the course of fighting that war that a general taste for travel was created. So did the general wealth that Americans enjoyed during the post-WWII years. Rather that settling for a week at the nearby lake, families wanted to go to Florida or California...or Paris...for their vacations.

The more mobile population **overwhelmed the existing credit agencies**. A more scientific system was needed to track information on tens of millions of people. The plastic credit cards helped.

And the credit bureau system that the U.S. has now began to take shape.

CREDIT BUREAUS' CUSTOMERS

Ironically, the newer system took on some of the traits of the original mutual protection societies. For one thing, consumers couldn't access their own credit histories. Only lenders, credit card providers and other businesses had access to credit reports.

Modern credit bureaus were created to service lenders, not borrowers. Lenders want to be repaid, and the credit bureaus help them figure out which consumers are most likely to do so on a timely basis.

The bureaus' primary focus remains on serving lenders. But a number of factors have led them to become more consumer-friendly. These factors include:

- growing concern over errors in consumers' credit histories;

- the rise of identity theft and other fraud; and

- the Fair Credit Reporting Act.

Today, you can get your credit score, or copies of your credit reports, through a variety of sources online or by mail. Plus, lenders will usually tell you your credit score when you apply for a loan.

American consumers really began finding out about credit scoring—and **demanding to see their scores**—in the 1980s. The Internet boom of the 1990s hastened this process, as more information was available in more places.

In 2000, the on-line lender E-Loan.com offered to give consumers their **scores for free**, with information explaining how the score was calculated and how they might improve it. Fair, Isaac & Co. responded by cutting E-Loan off from its credit formulas, effectively crippling its ability to lend money. E-Loan stopped giving away credit scores.

FAIR CREDIT REPORTING ACT

According to the FTC, the FCRA—which went into effect in 1971—was designed to ensure that **consumer reporting agencies**, or CRAs, "furnish correct and complete information to businesses to use when evaluating your application."

To help ensure the information is correct and complete, the Act ensures that consumers can check their own reports and make changes to them, if necessary.

As a consumer, you have a number of rights under the FCRA. These include:

- the right to **receive a complete copy** of your credit report;

- the right to know the name of **anyone who has received a copy** of your credit report within the last year—or within the last two years, if it was for employment purposes;

- the right to know the **name and address of the CRA** a lender, credit card provider or other company has contacted, if that company denied your application for credit;

- the right to a **free copy** of your credit report if you've been turned down for credit because of information in that credit report;

- the right to **contest the accuracy or completeness** of the information in your credit report, both with the CRA

and with the company that provided that information to the CRA;

- the right to **an investigation by the CRA within 30 days** of you reporting an inaccuracy, as well as the right to have the company that provided information you question in your credit report investigate it;

- the right to have **inaccurate information removed** within 30 days, and the right to have the CRA that removes the information report it to the other CRAs;

- the right to **add a "summary explanation"** to your report if you are unhappy with the way a dispute over an inaccuracy is resolved;

- the right to **restrict access to your credit report** to people who have a "permissible purpose" (see Chapter 7 for more on who can access your report);

- the right to **remove your name** from lists that CRAs sell to marketers; and

- the right to **sue for damages** if someone accesses your report without "permissible purpose" or violates one of the other provisions of the FCRA.

WHAT'S IN YOUR REPORT?

The first thing you should know is that your three credit reports probably are not the same. Lenders, credit card companies and other businesses supply

information to the credit bureaus **on a voluntary basis**. So they may only provide your information to only one agency, or to two or three or none. That's why it is so important to check all three of your credit reports.

In each case, you'll find that the credit report is divided into four sections:

- identifying information;
- credit history
- inquiries; and
- public records.

We'll go through each section and let you know what to look for.

IDENTIFYING INFORMATION

The **identifying information section** on your credit report is straightforward. It is compiled using the information you provide when you apply for credit.

This can include some or all of the following:

- your name,
- your current address.
- one or more of your previous recent addresses,
- your telephone number or numbers,
- your Social Security number,
- your driver's license number,

- your birth date,

- your spouse's name,

- home ownership information,

- your income,

- your current employer, and

- your previous employers.

If you find more than one spelling of your name in this section—or even more than one Social Security number—don't be surprised. It is simply because someone has reported the information incorrectly.

In a rather selfish move, most credit bureaus leave the incorrect information on there to ensure that future reporting from that same company will go on the correct credit history.

CREDIT HISTORY

This section lists the accounts that you have with different **lenders, retail stores, credit card companies** and other businesses, including accounts on which you are listed as an authorized user (such as your spouse's credit card).

It includes the **account numbers** for each account, although these may be scrambled for security reasons. Sometimes, you'll find more than one account number for the same creditor. This could be because you moved or because the creditor assigned

more than one account number to you. This isn't necessarily a cause for concern.

The **payment history section** does provide a great deal of detail, including:

- the **date** you opened each account;

- the kind of account (i.e., an installment account, such as a home or car loan, or a revolving account, such as a Visa or a gasoline credit card);

- whether it is in **your name alone** or with someone else;

- the **credit limit**, the amount of a loan or the highest balance on a credit card;

- the **monthly payment** amount if it's fixed (such as on a car loan), or the **minimum monthly payment** if it varies (such as on a credit card);

- the **outstanding balance**; and

- whether there were any **missed or late payments**.

If you have a **past-due account**, the report may indicate whether it has been referred to a collection agency. That makes a difference; an account that's been "sent to collection" is a much bigger black mark on your credit score than one that's just late.

You also may find information about **closed or inactive accounts**. These can remain on your report for seven to 11 years, depending on the manner in which the account was paid—or not paid.

INQUIRIES

Credit bureaus keep a record whenever **someone views your credit** history. These inquiries are made by lenders, landlords, credit card providers, service providers and insurance companies. A record of these inquiries will remain on your credit report for one to two years.

There are actually two kinds of inquiries: **hard** and **soft**. The consumer version of a credit report includes both kinds, but the version that is provided to businesses shows only hard inquiries.

Any credit application or an application to lease an apartment will usually generate a hard inquiry.

Soft inquiries include your own request for your credit report and job-related requests.

Also, CRAs often provide your contact information to companies that market to consumers with a certain type of credit history. This includes credit card issuers that send out pre-approved card offers.

Companies that have received your information for marketing purposes will show up in the soft inquiries section, but these companies have not actually seen a copy of your credit report.

Janet Rosen had a high credit rating, so she fell into a group of creditworthy consumers whose contact information was sold by the credit bureaus.

Janet received "pre-approved" offers for credit cards all the time—at least one each week. After months of these offers through her shredder, she finally decided to apply for a card from Wells Fargo, the same bank that wrote the mortgage on her house.

Janet was shocked to receive a rejection letter. As required by law, Wells Fargo stated in the letter:

- which credit bureau it had received her credit report from; and

- what item in the credit report triggered the denial of credit.

While Janet's credit score was above 700, she did have an eight-year-old bankruptcy on her credit report. And that caused Wells Fargo to deny her application for a credit card—even though the company had been soliciting *her*.

If you don't want credit bureaus to sell your name to credit card providers and other companies, you can opt out. You can do so by contacting each of the credit bureaus directly. Or you can call 888-5-OPTOUT (1.888.567.8688) to have your name removed for two years from mailing and telemarketing lists that come from the big three bureaus.

PUBLIC RECORDS

Many types of events are a matter of public record—that is, the kind of information you can find out if you pay a visit to your local courthouse.

These types of events may appear in this section of your credit report. They can include:

- bankruptcies;
- tax liens;
- foreclosures;
- court judgments; and
- overdue child support.

This information usually will remain on your credit report for seven years.

WHAT'S *NOT* IN YOUR REPORT

As surprising as it can be to learn just how much detail about your life is available to creditors and even to companies in search of potential customers, it may be even more surprising to learn what's *not* in your credit file.

Your credit report does not contain information on:

- savings or checking accounts;
- bankruptcies that are more than 10 years old;
- charge-offs or debts that have been sent to collections that are more than seven years old;
- driving records;
- medical history (although medical bills may appear on your report as debts); or

- criminal records.

For privacy and fair lending reasons, the credit report also cannot include your:

- gender;
- ethnicity;
- religion; or
- political affiliation.

CREDIT REPORTS VS. SCORES

Credit reports can be several pages long, so it's not surprising that credit scores were developed as a sort of shorthand—and as a more objective way to evaluate consumers.

In order to determine your credit score, some of the information in your credit report is fed into a mathematical formula, which spits out the three-digit number that lenders use to predict whether you are likely to pay back a loan (or a credit card debt) **in full and on time**.

As we've noted, supporters of credit scoring point out that it has created more uniformity in lending, in part by removing the subjective human factor. Instead of having loan officers look over your credit report and application—filtered through their own judgments, experiences and biases—the process is now largely automated.

What's more, many lenders now rely on the **same criteria** in judging applicants for credit, where in

the past each lender might have had its own (often conservative) method for determining a consumer's creditworthiness. But there are still complaints.

According to an article in the Philadelphia Federal Reserve Bank's newsletter, *Cascade*:

> *Opponents argue that an automated system will not consider the unique needs of low-income and other nontraditional borrowers. As a result, opponents believe, loan denial rates will increase.*

As we've noted, Fair, Isaac & Co. invented the most widely used credit score program. Its proprietary formula is used by most creditors to determine the so-called **FICO score**, though there are other formulas that have been created for different purposes.

The Big Three credit bureaus all use the FICO formula to compute credit scores, but each calls that score by a different name. Equifax calls it the *Beacon* score. Experian calls it the *Experian/Fair Isaac Risk Model*. And Trans Union calls it the *Empirica* score.

WHAT MAKES A CREDIT SCORE

Fair, Isaac's credit scoring formulas take into account and weigh various pieces of information from your credit report. The information and weights include:

- the **type of accounts** you have (mortgage, car loan, credit cards), 10 percent;
- the number of **recently opened accounts** and their proportion to your overall credit, 10 percent;

- your **payment history**, 35 percent;

- the **amounts you owe**, 30 percent; and

- the **length of your credit** history, 15 percent.

The emphasis placed on the various parts of your credit report can vary. Fair, Isaac & Co. notes:

> *These percentages are based on the importance of the five categories for the general population. For particular groups—for example, people who have not been using credit long—the importance of these categories may be somewhat different.*

Other scoring models use essentially the same information, though the emphasis may vary.

When considering your payment history, the FICO scoring system looks at:

- your account payment information on specific kinds of accounts (including mortgages, installment loans, credit cards, retail accounts, finance company records and so on);

- public records, especially a bankruptcy, liens, judgments against you, wage attachments and such;

- whether anything is past due, and how long it has been past due;

- how much is past due or has been turned over to collections;

- the number of past due items in your credit history;

- the length of time since a bankruptcy or a past due or any other negative item appeared on your history;

- the number of accounts that have been paid on time and as agreed.

The **length of your credit history** is important in determining if there is enough information on which to base a credit score.

The credit report being used to generate a score also has to have at least one account that has been updated within the previous six months, so that there is enough recent information on which to base a score.

You'll also find that some lenders use their own scoring system. For instance, according to the Philadelphia Federal Reserve Bank's newsletter:

> *Application scoring systems, which look at both credit bureau information and information submitted on an application, consider employment stability, debt-to-income ratios, assets (particularly cash) and loan-to-value ratios.*

YOUR SCORE AND CREDIT

Your credit score will have a profound effect on whether or not you qualify for a loan, a credit card or some other form of credit.

What's more, your score will influence the **price you have to pay** for that credit. The higher your score, the lower your interest rate.

Your credit score can even have an effect on credit cards you already have. That's because some card issuers check your credit score before increasing your credit limit—or increasing your interest rate.

> **Fair, Isaac claims that, if your FICO score is 720 or higher, you will usually qualify for the best available interest rate on a mortgage.**

So, you don't need to improve your credit score if it's 720 or higher, since you're already getting the best deals on credit. However, if your score is 719, you will definitely want to take steps to boost it.

> **The difference, in terms of cost of credit, between a score of 719 and 720 can be fairly substantial when it comes to borrowing money. And the difference between a score of 620 and a score of 720 can be really dramatic.**

If you're looking at a 30-year fixed-rate mortgage of $200,000, the following chart shows the effect your credit score will have on the interest rate you receive, the monthly payment you'll have to make and the total amount of interest you'll pay over the life of the loan. (The interest rates shown are averaged based on the rates offered by many different lenders. They are a snapshot and may not be timely when you're reading this book. But **the comparisons should remain useful.**)

FICO Score	APR	Monthly Payment	Total Interest Paid
720-850	5.677%	$1,158	$216,839
700-719	5.802%	$1,174	$222,554
675-699	6.340%	$1,243	$247,539
620-674	7.490%	$1,397	$302,942
560-619	8.531%	$1,542	$355,200
500-559	9.289%	$1,651	$394,362

So, if you have a score of 620, you'll be paying $86,103 more over the term of a 30-year loan than you would if you had a score of 720. And if you have a score of 520, you'll be paying $177,523 more than if you had a score of 720—not to mention $493 more each and every month.

To see how your credit score affects your rates, visit **Fair, Isaac & Co.'s Web site**, (www.myfico.com) and use the Loan Savings Calculator.

CONCLUSION

Your credit score reflects how reliably you've paid your bills in recent years. It indicates how much interest you'll pay on loans and financing. A low credit score can means hundreds of dollars a month in higher interest rates.

This is the **purpose of credit scores**. If you have a history of paying late, you pay more.

How long your past experiences affect your score varies. In general:

- missed payments remain on your report for seven years;

- most public record information remains on your report for seven years;

- Chapter 7, 11 and 12 bankruptcies remain on your report for 10 years; and

- unpaid tax liens remain on your report for 15 years.

Lenders don't like to see too much debt on your credit report. Having too many credit cards with high balances makes you a **less appealing risk**. So does having a lot of credit cards with high credit limits, even if you haven't run up big balances.

We'll consider all of these issues in greater detail later in this book. In this chapter, we've just focused on the mechanics of credit scores.

HOW CREDIT
CARDS WORK

There are essentially two kinds of consumer credit available to you: secured and unsecured.

Secured credit is attached to some sort of collateral. For instance, when you take out a loan to buy a house, the house itself is collateral. The same goes for buying a car, a boat, a motor home, a trailer or a personal watercraft.

In the event that you stop paying back the money you owe, the secured lender can repossess your car or foreclose on your house. In other words, the company can take possession of the collateral; and that gives the lender some confidence in extending you credit.

Unsecured credit is different. In this case, there is no collateral. The lender has to take a much greater risk in assuming that you will pay back the money you owe.

Examples of unsecured credit include:

- credit cards;

- department and specialty store charge accounts;

- student loans; and

- signature loans.

Unsecured debt can also include such things as medical bills, legal bills, cellular telephone bills, bounced checks and health club memberships.

Unsecured lending can be risky business. According to the Federal Trade Commission (FTC), nearly 1.5 million consumers filed bankruptcy in 2001—primarily to get out of repaying unsecured debt.

A HISTORY OF CREDIT

Merchants have offered credit to consumers for thousands of years. In fact, some of the oldest written documents in existence—from the Babylonian and Assyrian cultures at the dawn of the Bronze Age—are records of credit accounts.

But credit in older times was a decidedly undemocratic and unscientific process. Merchants offered credit to people they knew personally...or who came recommended by people the merchants knew and trusted. This limited the number of people who could by any one merchant's goods.

It also left merchants—and whole economies—reliant on a relatively few people and even fewer sources of income. If one family moved or one crop

failed, a whole economy could be wiped out. Smart bankers and traders could diversify an economy somewhat; but most realized that everyone would benefit from an **organized system** of issuing credit.

The use of credit cards originated in the United States during the 1920s, when individual companies—such as hotel chains and oil companies—began issuing them to customers for purchases at company stores in different cities. For the growing number of Americans who travelled around the country, the convenience of a card that was accepted in Oregon as well as Mississippi was a real value.

This use increased significantly after World War II, when veterans returned and looked for the chance to travel for business and pleasure.

The first **general-purpose credit card**—one that could be used at a variety of stores and businesses—was introduced by Diners Club, Inc., in 1950. In this system, the credit-card company charged cardholders an annual fee and billed them for their charges on a monthly or yearly basis. Another major card was established in 1958 by the American Express company.

Later came the **bank credit-card** system. Under this plan, the bank credits the account of the merchant as sales slips are received (this means merchants are paid quickly—something they like) and assembles charges to be billed to the cardholder at the end of the billing period. The cardholder, in

turn, pays the bank either the entire balance or in **monthly installments** with interest (sometimes called carrying charges).

The first national bank card plan was BankAmericard, which was started in 1959 by the Bank of America in California. The system was licensed in other states starting in 1966 and was renamed **Visa** in 1976.

Other major bank cards followed, including **MasterCard**, formerly Master Charge. In order to offer expanded services, such as meals and lodging, many smaller banks that earlier offered credit cards on a local or regional basis formed relationships with large national or international banks.

Early credit cards were made of cardboard and required merchants to write down the cardholder's name and account information. In the 1950s, the cards were made from plastic and included raised names and numbers that could be imprinted onto carbon sales slips.

In the 1970s, card companies started using **magnetic strips** on the back of the cards, which contained all the relevant information and allowed computer systems to track a cardholder's use. By the 1990s, card companies were experimenting with computer chips embedded in the plastic of the cards.

But the magnetic strip still oils most of the wheels of modern merchant commerce.

THREE KINDS OF CREDIT CARDS

While we tend to think that a credit card is a credit card, there are actually three different kinds of cards available today. They are:

- a card offered by a bank;
- a travel and entertainment card; and
- a "house card."

You've probably noticed that thousands of banks offer credit cards. And all of those credit cards carry the Visa or MasterCard logo, along with the bank's name.

Visa and MasterCard **do not offer credit cards directly** to consumers.

Visa is a privately held membership association. It's owned by 21,000 member financial institutions around the world, and virtually all of those members offer Visa credit cards. Likewise, MasterCard has approximately 25,000 MasterCard, Cirrus and Maestro members worldwide.

These types of credit cards are **"revolving" credit accounts**. You can pay all or part of your balance each month, pay off the card, run up the balance again and so on. However, your account will come with a preset credit limit, which can be as low as $100, as high as $40,000—or even higher.

Because bank cards' terms and conditions vary dramatically, we'll devote an entire chapter later on to **choosing the right credit card** for your needs.

Travel and entertainment cards are different. They are not offered by banks. Instead, they are offered directly by American Express and Diners Club.

> No matter where you apply for an AmEx or Diners Club card, you will get the same terms and conditions. What's more, both American Express and Diners Club cards come with no preset spending limit.

In most cases, you will have to pay your balance in full each month on an American Express card. Diners Club is similar, but it gives you two months to pay without incurring penalties (which is designed to appeal to travelers who take long trips).

Both travel card providers also offer many of their customers **year-end summaries** of their charges, which can be useful at tax time, when tallying travel and entertainment expenses.

Unlike bank cards and travel and entertainment cards, which can be used in a variety of businesses and locations, **house cards** can be used only at a specific chain of stores.

Major issuers of house cards include:

- department stores (Sears is the biggest issuer of house cards, overall);
- oil and gasoline companies; and
- telephone companies.

And then there are specialty cards, like the one you can get at your local tire center.

Like travel and entertainment cards, most house cards come with the same **terms and conditions**, regardless of where you apply. Like bank cards, most house cards are **revolving accounts**, so you do not have to pay your bill in full each month.

HOW MERCHANTS GET PAID

Have you ever wondered how money flows to a company when you use your bank or travel/entertainment credit card to purchase a product or service?

First, the company that sells you the product or service has to have a **merchant card services account**. This account enables the company to accept credit cards.

This is how a basic, retail credit card transaction works: After you or the cashier swipes your credit card through a reader, software at the point-of-sale (POS) terminal dials a telephone number (using a modem or Internet connection) to call an **acquirer or processing company**.

The acquirer is an organization that collects credit-authentication requests from merchants and provides the merchants with a payment guarantee.

When the acquirer gets the credit card authentication request, it checks the **transaction for validity** and the **record on the magnetic strip** for:

- merchant ID,

- valid card number,

- expiration date,

- credit-card limit, and

- card usage.

Once these items have confirmed, the processing company approves the charge. It is then responsible for making sure the proper bank accounts are debited and credited. And it takes responsibility for resolving **errors or fraudulent charges**.

The processing company doesn't do this for free. It makes money on every single credit card transaction. In most cases, the processing company gets both **a per-transaction fee** and **a percentage of each sale** (also known as the discount rate).

So, to fill in some numbers, when you spent $100 at the flower shop, the processor may have received $0.25 as a transaction fee, plus 2.2 percent of the sale, or $0.022.

Of the $100 you paid, the credit card processor got $0.272.

After the transaction has been processed and the money has been allocated to the processor, the $99.728 due to the florist is deposited into the company's bank account. Some processors also enjoy a "float" period—often one, two or three days-during which they hang onto the merchant's money before depositing it into the bank account.

Some merchants get **more favorable terms** than others when it comes to accepting credit cards, but the above numbers are fairly common.

> For small purchases, of course, the per-transaction fee can dramatically reduce a merchant's income. That explains why many businesses have a minimum credit card charge amount.

And for large purchases, the discount rate can take a pretty good bite out of the merchant's revenue.

The reduced income from accepting credit cards does explain why some companies will encourage you to pay them in cash or with a check.

Plus, whenever you use a credit card, there is a risk that you will "chargeback" the amount of your purchase—i.e., dispute it with the credit card issuer. The issuer then will go back to the merchant to get a refund, along with a penalty fee (often in the neighborhood of $25).

THE WEB OF RELATIONSHIPS

The various relationships among merchants, processing companies, card issuers and card holders can create a lot of confusion when **mistakes** are made...or when **fraudulent charges** occur. This is why credit card companies and processing companies take fraud so seriously.

The September 2002 California state court decision *Payment Resources International v. Bankcard Processing* shows how badly things can go among the various players.

In May 2000, Payment Resources International (PRI) entered into a contract with Bankcard Processing and its two principals—Kenneth Collis and Gonzalo Ramirez.

Under the agreement, Bankcard was to obtain merchants for PRI to provide credit card processing with Visa and MasterCard. Bankcard also agreed to be responsible for any charges assessed against PRI by Visa/MasterCard or any acquiring banks as a result of fraudulent activity.

Bankcard retained Frank Navarro as one of its representatives in the eastern United States in November 1999. Three merchants (Samer Enterprises, Inc., Safir Electronics and Imma Wedding Transportation) were submitted by Navarro for credit card processing.

PRI relied on the applications of these merchants—which contained false information. PRI insisted that, if it had been given accurate information, it never would have set up the merchants for credit card processing. PRI also contended that, within a three week period, Navarro and **these merchants incurred $869,310 in fraudulent charges**, all of which were eventually charged back against PRI by Visa/MasterCard and two acquiring banks.

Chargebacks—the term for credit card charges that are denied or declined after the processing company initially approves them—are a big problem in the credit card industry. They are the equivalent of bounced checks, except they're even worse for banks because money has already been credited...and has to be recovered from a merchant.

PRI then filed a lawsuit against Bankcard seeking **reimbursement of funds** for the fraudulent activity on Bankcard's merchant accounts.

PRI further argued that Bankcard and its principals breached the written contract when they failed to pay for the charges that were assessed against PRI. It also claimed that **Bankcard was a bogus corporate shell** for Collis and Ramirez. According to PRI, neither of the men made any effort to observe corporate procedures properly and both abandoned the company as soon as PRI started to realize the fraud being perpetrated.

In response, Bankcard and Collis and Ramirez argued that the contract with PRI was one of adhesion and that **they didn't understand** that they would be responsible for any amounts charged by the acquiring banks against PRI. They also denied any direct relationship with Frank Navarro, claiming he was actually PRI's agent.

Collis and Ramirez insisted that they observed all proper corporate procedures and that, if any liability should be found against them, it should be found

only against Bankcard—and not against them, individually.

Following a four-day bench trial, Judge Michael Naughton found in favor of PRI and awarded $869,310. The court also found, based on the contract and the negotiations between the parties—along with **standard practices in the credit card industry**—that it was clear that Bankcard and the two individual defendants were responsible for any chargebacks due to fraudulent activities of Navarro and any other agents.

> **If all of these behind-the-scenes mechanics seem too complex to understand...you're not alone. Even banking industry insiders marvel that the system works as effectively as it does.**

A COMPLEX SYSTEM

The key is the **processing companies**—rather than the banks issuing cards—who act like the air traffic controllers for the system. The processing companies keep the transactions flowing.

But when these companies trip up, the fallout can be ugly—and show just how much power the processing companies have give and take money. The Alabama state court decision *Pushmataha Plantation v. Nova Corp. et al.* offers one example.

Pushmataha Planation was a tourist destination in Alabama. Nova was one of the largest credit card

processing companies in the U.S. Pushmataha sued Nova for damages related to alleged **illegal, improper and unrelated fees** that Nova charged to Pushmataha's merchant accounts.

In June 1998, Pushmataha entered into a merchant bank card services agreement with Nova and purchased point-of-sale equipment from Nova for the purpose of processing credit card transactions.

In January 1999, Pushmataha received a statement for the month of December 1998 from Nova. In this statement, the plantation was informed for the first time that it would be assessed a **one-time fee** of $40 for Year 2000 compliance efforts Nova had made on its behalf in 1998.

In February 1999, Pushmataha received a statement for the month of January 1999. In that statement, the plantation was informed that Nova had charged a "miscellaneous fee" of $40.00.

The plantation claimed that Nova's practice of charging **miscellaneous fees** was improper and not supported by any contractual agreement between the two parties. The plantation went on to argue:

> *...No disclosure is made at the time of the merchant services agreement that these charges will be imposed and no agreement is reached whether the customer agrees to pay these charges or fees. The fees and charges are imposed unilaterally by {Nova} without prior disclosure to the customer.*

The plantation wanted the court to certify a class action lawsuit against Nova; Nova wanted the court

to throw out the plantation's lawsuit entirely. The court didn't throw out the lawsuit…so Nova started to negotiate a truce with Pushmataha.

WHAT THIS MEANS TO YOU

The inner workings of the credit card processing system may not mean so much to any individual cardholder—to *you*—directly. But a basic understanding of the mechanics should give you some idea of how impersonal the whole system is.

Card issuers (let alone card processors) don't really care who you are or what your story is. All they care about is that you **keep the money flowing** through the system—and you do that by paying your bills on time. Period.

With travel and entertainment cards that do not allow you to run up an outstanding balance, a good borrower pays **the full amount** of what he or she charges each month by the assigned due date.

In the case of revolving credit card accounts, a "good" borrower pays at least **the minimum monthly payment** indicated on the credit card statement—again, on or before the due date.

While some consumers believe that paying off their revolving credit card bill in full each month makes them a "better" borrower, that depends on your perspective. Certainly, many financial advisers will suggest that you **maintain zero balances** on your credit cards whenever possible.

But credit card providers make money by charging you interest when you run up a balance. Card issuers like consumers who maintain an outstanding balance—up to a point. And that point is usually about 20 percent of your monthly income.

> **So, maintaining at least a small balance and then paying it off over time can be better, overall, for your credit rating than paying your bill in full each and every month.**

If the "good" borrower pays the right amount on time each month, you'd expect that the "bad" borrower would do just the opposite—and you'd be right. **Bad borrowers pay late**, if they pay at all.

CONCLUSION

If you loaned your brother-in-law a thousand dollars, under the agreement that he would pay you back $50 a month for 20 months, you'd be upset if he didn't pay you one month. You'd be really upset if he didn't pay you for two months. In fact, it might cause all kinds of family disharmony.

Professional money lenders feel pretty much the same way, aside from the family strife.

If you don't pay your credit card bill on time one month, you'll get smacked with **a late fee and possibly other penalties**.

You also may **hurt your credit score**—particularly if you get two months behind in payments.

In some cases, you aren't just late in making payments. You're not making payments at all. Then, the loan is considered **in default**—and your creditor likely will send it to a collection agency to try and get you to make good on your debt.

Once a creditor completely gives up getting repaid by you, the company writes off your debt on its taxes, and your account is considered a charge-off.

> We'll consider these black marks in greater detail later. For now, it's enough to say that lenders share information about their customers with other lenders to help reduce the risk of future defaults and charge-offs.

Most credit card issuers prefer to lend money to someone who has demonstrated a history of paying his or her bills on time. On-time payments make the complex system run a little more smoothly.

CHOOSING A
CREDIT CARD

If you've got reasonably good credit, odds are you receive credit card offers in the mail all the time. Some of those offers may sound pretty tempting, too—with high credit limits and low interest rates.

But before you fill out any application, you'll want to read the fine print—and **shop around**.

Although the government regulates the interest rates and other financial aspects of credit cards, the marketplace is **incredibly diverse**. Some cards offer cash back or frequent-flier miles based on your spending—but penalize you steeply for making a late payment. Others are more generous with grace periods—but charge a lot if you spend over your credit limit. Some cards make it easy to get cash advances—but charge you a higher interest rate than on ordinary charges.

As a smart consumer, you need weigh the pros and cons of each credit card you consider. And, before you do that, you need to know what the pros and cons *are*.

The basic terms of use for every credit card are:

1) interest rate (often called APR);

2) grace period;

3) finance charges;

4) annual fee;

5) cash advance fees;

6) late-payment charges; and

7) over-limit fees.

We'll consider each of these terms in detail in this chapter. But, before we do that, we should raise the important point that who you are can affect what kind of credit card you should use.

WHO ARE YOU?

Using a credit card is a simple form of borrowing. And anyone who borrows money should know a few things about himself or herself before signing any agreements.

> You need to consider your life-style and payment style. Are you an impulsive shopper? Are you a bargain hunter? Are you frugal? Spendy? Do you pay your bills on time? Are you not so organized?

There are no right answers to any of these questions. The point is that, as we consider the mechanics of different kinds of credit cards, you should

keep in mind what kind of credit user you are. This influences the kind of *card* you should use.

> **If you pay your bill in full every month, the interest rate is not going to be as important as other card features, like frequent-flier miles or no annual fee. But if there's even a remote chance that you might run a balance, you'll want to focus on finding a card with a low APR.**

INTEREST RATES

Many people choose a credit card based on its advertised interest rate. (This rate is usually referred to as the annual percentage rate or "APR.") But the **advertised rate** is by no means everything you need to know to avoid an unpleasant surprise later.

Actually, a credit card can come with **several different interest rates**. Before you apply for a card, you'll want to learn the rates it charges for:

- purchases;
- cash advances; and
- balance transfers.

These rates can be dramatically different. And the differences may affect a card's appeal.

For instance, if you have a steady income but are carrying a lot of credit card debt from a time when you didn't, you may want to transfer older balances from high-interest-rate cards to a lower one. In that

case, you'll want a card with a low rate for balance transfers...but you can live with a high rate for cash advances (since you shouldn't need them).

You'll also need to read the fine print to determine whether the advertised APR for balance transfers—or for purchases—will **remain fixed**.

> **Some credit card companies offer a low introductory APR to attract new customers and even get them to transfer the balance from another card, but the low rate is only good for a short time.**

If the transfer rate is temporary (an introductory or **promotional rate**, in industry jargon), you may still be interested...because you'll pay off the balance before the end of the promotional period.

If you *do* pay off the balance within that period, congratulations. You're in the minority. According to Bill Free-American Credit Counselors, 53 percent of Americans still have most their balance left on the card at the end of the promotional period.

Some cards have a steady interest rate, while others—and their numbers are growing—have rates that fluctuate dramatically. The three common kinds of APRs for credit cards are:

- fixed;
- variable; and
- tiered.

A **fixed interest** rate will remain the same for as long as you have the card—unless the credit card company notifies you of an interest-rate change.

You'll also want to read the fine print regarding actions on your part that can affect the interest rate. Some card issuers will raise your rate if you make **late payments**. If the card you're considering has a "penalty rate," the credit card issuer must mention it in the solicitation materials.

A **variable interest** rate will change over time. It typically is based on an index, such as:

- the prime rate;

- the 1-, 3- or 6-month Treasury Bill rate;

- the federal funds rate; or

- the Federal Reserve discount rate.

You can find these indexes listed on-line or in the money or business section of your local newspaper. When the index on which your card is based changes, so will the interest rate you have to pay.

If you have a credit card with a variable interest rate tied to the prime rate, and you start hearing that interest rates for home loans are rising, you can expect the interest rate on your card to go up, too.

But *how* the index is used is actually more important than which index your credit card company chooses. When comparing cards with a variable in-

terest rate, you will want to know how that rate is computed. The three most common ways are:

- Index + Margin = Rate

- Index x Multiple = Rate

- (Index + Margin) x Multiple = Rate

These formulas can **make a big difference** in how much interest you pay.

The credit card issuer will choose the multiple, which can be any number. It will also choose the margin, which is expressed as a number of percentage points. So, the interest rate on a particular card could be the prime rate (index) plus 2 percent (margin).

If you are considering a variable-rate card, you'll also want to learn whether there are caps on how high or low the interest rate can go. There usually are; the closer the high and low cap, the better.

The third common APR arrangement is a **tiered rate**. In this case, the outstanding balance on the card is charged at different rates for different levels. For example, the company might charge 16 percent interest on a balance of $1 to $500, and 17 percent interest on balances above $500.

Another example: A card that's tied to a zero-percent-interest offer at certain retail locations. A variety of retail establishments offer special promotions where you can buy a new TV or a mattress or a wide variety of other products and pay no interest for

several months. Typically, you have to open a new credit card account (sometimes a Visa or MasterCard with the retail establishment's logo on the face) to get this special interest rate.

You should read the fine print carefully **before you apply** for one of these tiered cards (something you may not be able to do comfortably when you're standing in line at the checkout counter, where these cards are normally "sold").

While zero-percent interest is enticing, don't make the mistake of thinking *anything* you buy with the card will be interest-free. If you run a balance on any additional charges, they'll be computed at the card's normal APR, which can be pretty high.

Also, you should learn how your payment will be allocated to the zero-percent-interest balance versus the higher-interest balance.

You might expect your payments to be allocated to the higher-interest balance first; but this typically is *not* the case. Often, your payments are applied to the zero-interest balance until it is paid off in full, while the interest multiplies fast on any other purchases, transfers or cash advances you make.

If the card uses this tactic, make sure you don't use it for casual purchases.

As we've mentioned before, a **zero-interest promotion usually has a limited life-span**. If you don't

pay off the promotional balance in time, you can get stuck paying all the interest you would have owed at the card's normal rate.

PERIODIC RATE

Because "APR" is the abbreviation for annual percentage rate, and because credit card issuers send out their bills monthly, they do not use the APR to calculate the finance charges you owe in a given billing cycle.

Instead, they use what's called the **periodic rate**. This is the APR divided by 12 (as in 12 months). So if your card has an APR of 12 percent, the periodic rate would be 1 percent.

That explains why you'll see periodic rate for new charges on your credit card bills, along with the APR for your outstanding balance.

GRACE PERIOD

If you pay your bill in full each month, on time, you can avoid being charged interest. The time during which you can enjoy the use of the issuer's money interest-free is known as the **grace period**.

Most credit card issuers describe this in a rather complicated way. They say that the grace period extends for a certain number of days **after your credit card statement date**. (The statement date is the date on which the bill was prepared by the card issuer, *not* the date on which you receive it. You

may receive it as long as two weeks after the statement date.)

The grace period often is 25 days, but some companies have reduced it to 20 days. A short grace period can mean that, by the time you receive the bill, you're already racking up interest charges. In this case, you may need to check your account by telephone or on-line and pay your estimate of the bill **before the statement arrives** each month.

If you plan to pay your bill in full each month, you want to be certain you get a card with a **longer grace period**, so you avoid interest charges.

Also, check the fine print for language that says the credit card provider can change the grace period at its discretion, since this can have a profound effect on how much interest you wind up paying.

And look for wording that refers to a **double billing cycle**. In this case, the due date to send in your minimum payment is different from the due date to pay off your outstanding balance, interest-free. In some cases, to avoid interest charges, you may have to pay your bill two weeks before the stated due date.

FINANCE CHARGES

To make matters a bit more complicated, different credit card issuers calculate finance charges in dif-

ferent ways. Some card companies give you a stretch during which no interest is charged for your new purchases; others start the finance charge meter running the minute you make a purchase.

It all comes down to whether or not the company **includes new purchases** in your outstanding balance, which is the amount on which finance charges are computed.

Credit card issuers can calculate your outstanding balance in a variety of different ways. These include:

- average daily balance method, *including* new purchases;
- average daily balance method, *excluding* new purchases;
- two-cycle average daily balance method, *including* new purchases;
- two-cycle average daily balance method, *excluding* new purchases;
- adjusted balance method; and
- previous balance method.

With the **average daily balance method**, your outstanding balance is averaged for the billing cycle. So, the company adds up the outstanding balance for each day during the billing cycle, taking into account any payments you may have made or credits received, then divides by the number of days in the billing cycle.

Whether or not the company includes new purchases in this balance can make a big difference in

the finance charge you pay. If the company excludes new purchases, you essentially get to own those products interest-free until the beginning of the next billing cycle.

The **two-cycle average daily balance method** works much the same way, except it takes the current and the preceding billing cycle into account in computing the outstanding balance.

The **adjusted balance method** is perhaps the easiest to understand. It's simply the outstanding balance at the beginning of the billing cycle, less any payments or credits during that billing cycle.

Finally, the **previous balance method** is the outstanding balance at the beginning of the billing cycle (ignoring any payments in the interim).

The methods that normally result in the **lowest finance charges**—and, therefore, work best for the consumer—are:

- the average daily balance method, *excluding* new purchases;
- the adjusted balance method; and
- the previous balance method.

LOOK FOR THE "SCHUMER BOX"

Credit card companies have to provide certain information in any offer that they make to you, under the federal Truth in Lending Act (TILA).

You can find this information printed in what's known as the "Schumer box" (after the U.S. Senator from New York who drafted the bill), which is required under TILA.

This box will appear **on the back of the letter offering you credit**, or on another sheet of paper enclosed in the same envelope.

The credit card issuer must tell you:

- the APR or APRs;
- finance charges, including the minimum finance charge;
- the minimum payment required;
- the method used for computing your outstanding balance;
- the actual company offering you credit (sometimes not the company marketing the card);
- the credit limit;
- the grace period;
- the annual fee, if any; and
- the fees for credit insurance, if any.

In disclosing the APRs, the card issuer must make it clear whether there is an introductory or **promotional rate** and, if so, how long it will last.

Plus, it must disclose **the regular APR** for purchases, cash advances and balance transfers—as well as any penalty rate and what actions on your part will trigger the penalty rate.

> If the interest rate is variable, the disclosure box also must include information on how the rate is computed.

A class-action lawsuit in which consumers were fooled by the information provided in a solicitation letter illustrates the **importance of reading the Schumer box**—and the cardholder agreement that you receive when you get your credit card.

In the case, against New England-based Fleet Bank, the bank's letter promised that the 7.99 percent rate "is NOT an introductory rate. It won't go up in just a few short months." However, **13 months later, Fleet raised the interest rate**.

The court found this was a completely legal move on the credit card issuer's part, because the Schumer box said the rate could change if the cardholder failed to meet repayment requirements or upon closure of the account. Plus, the cardholder agreement said the bank reserved the right to change the terms of the agreement at any time.

U.S. District Judge John Fullam wrote:

> *The preliminary disclosure statement sent to {the cardholder} at the same time as the solicitation letter informed her that {Fleet} reserved the right to change the interest rate, upon due notice. The credit card agreement, which {the cardholder} signed (after her application had been approved) also contained an express provision giving {Fleet} the right to change the interest rate.*

Therefore, Fleet did not violate the disclosure requirements of the **Truth in Lending Act** or other parts of that law. In other words, *read the agreement.*

The TILA also applies after you've started using your credit card. For instance, lenders are required by the law to give you at least 15 days' notice before raising the APR on a fixed-rate credit card.

"CREDIT CARDS" THAT AREN'T

Some retail stores and direct mail companies will push hard for you to apply for what they call a "credit card" to buy their products. But be warned: These credit cards sometimes aren't.

The January 2000 Mississippi federal court decision *Willie and Emma Oliver v. Bank One, N.A.* dealt with one such scheme.

The Olivers bought a television home satellite system from a door-to-door salesman. The purchase was financed by the issuance of a "credit card" by Bank One in May 1995.

Bank One furnished disclosures pursuant to the TILA, as though the credit transaction was an opened-end or **revolving credit facility**...what most people think of as a *credit card*. But there were some differences. The limit on the card was almost exactly the purchase price; and no business other than the satellite company would accept the card.

The Olivers didn't like the satellite system and eventually stopped making payments on the card by

which they'd bought it. As a result, Bank One posted a negative item on their credit report. The Olivers sued Bank One.

Since the card couldn't be used anywhere, the Olivers argued that the deal should have been treated as a **closed-end credit purchase**. This would have made returning the system easier. Their lawyers argued that Bank One's failure to set the deal up as a closed-end transaction violated the disclosure requirements of TILA. The trial court noted:

The purpose of the TILA is to protect the consumer from inaccurate and unfair credit practices, and "to assure a meaningful disclosure of credit terms so that the consumer will be able to compare more readily the various credit terms available to him and avoid the uninformed use of credit."

The Olivers argued that Bank One's negative credit report constituted an "action to collect the debt" and was therefore covered by the TILA. But the trial court ruled that "merely providing a negative credit report does not constitute an action attempting to collect the debt under the TILA."

The court also ruled that the TILA's one-year statute of limitation prevented the Oliver's claims:

{Bank One} provided open-ended credit disclosures to the {Olivers} in connection with their purchase of a satellite dish system in May 1995, and the {Olivers} filed this cause in February 1999, nearly four years after the date of the alleged violation. As such, the dismissal of this action is further appropriate....

So, if you think you've got a TILA complaint, make sure to contact a lawyer within one year.

CASH ADVANCE FEES

Getting a cash advance from a credit card is a bad idea.

Most card issuers charge a hefty fee for a cash advance, usually in the neighborhood of 2 to 4 percent of the amount. Then, many charge more interest on cash advances than they do on purchases. And, on top of that, there's usually no grace period—so the higher interest starts piling up right away.

Also, your payments will be allocated to the lower-interest charges first, so the interest keeps building on the cash advance amount.

LATE FEES

Late fees are a classic example of "hidden fees"— ways the credit card issuers can extract just a little more money from consumers. Here's how they work.

Late fees seem pretty straightforward. If your payment arrives late, the credit card company sticks you with a penalty, usually in the $15 to $50 range.

Some card issuers have found creative ways to increase revenues from late fees. They actually stipu-

late a **time of day** when the payment is due, such as 1 p.m. (You'll find the time on your credit card bill, if your company plays this game.) So, if the letter carrier working the issuer's route is running late that day and the mail arrives at 1:05 p.m.—or if the mail *always* arrives after 1 p.m. at that location—even if your payment arrives on the correct day, you'll still get stuck with a late fee.

Also, some credit card issuers change their payment receipt addresses every couple of years. It doesn't necessarily have to be a malicious move in order to generate more fees; but, if you mail your check to an old address, you can wind up owing late fees.

Even if you pay your bills on-line, it's wise to check the payment address each month—just to make sure you know where mailed payments should go.

Another good reason to get your payments in on time is because multiple late fees in a specific time period (such as two late fees within six months) can trigger a credit card company to **assess a penalty interest rate** on some accounts. These interest rates can be exorbitant—as high as 23.99 percent—and they can last for the life of the credit card account.

What's more, some credit card companies check your credit report after they've already issued you a card. In some instances, card issuers look on consumers' credit reports for late payments *to other accounts*, then use that information as a reason to raise the interest rates on their credit cards.

OVER-LIMIT FEES

Most revolving or open-end credit card come with a **credit limit**. This limit can be as low as $250 and as high as...well, they can be unlimited but most standard cards peak at around $40,000.

Many consumers would expect their credit card to be declined if a transaction would put the card over their credit limit. But, increasingly, credit card companies are allowing these transactions to go through, then slapping consumers with an over-limit fee of $20, $25 or more.

> **This isn't necessarily a one-time fee, either. If your card balance remains over the limit, you'll get stuck with this fee every month until you pay down the balance sufficiently.**

Sharon Pfennig was angry enough about the late fees assessed on her credit card to sue the companies that provided it (Household Credit, which issued the card, and MBNA, which later purchased all of Household Credit's accounts). Particularly irksome: Pfennig had asked the credit card company to extend her credit limit so that she could make a purchase. The company agreed, but stuck her with an over-limit fee anyway.

In addition, the company did not include the over-limit charges in the finance charge on her bill. Instead, they posted the fee as a debit—and then proceeded to **include it in the outstanding balance,**

so they charged interest on the fee as part of the monthly finance charge.

That frustrated Pfennig, who alleged "that the foregoing results in an exorbitant penalty that often amounts to an annual percentage rate of nearly 60 percent on credit extended over the limit."

Now *that's* a penalty rate.

Credit card companies don't have to include any mention of over-limit fees or late fees in the Schumer box. You'd think this would be required, since TILA defines "finance charge" as:

> *...the sum of all charges, payable directly or indirectly by the person to whom the credit is extended, and imposed directly or indirectly by the creditor as an incident to the extension of credit.*

Certainly, late fees and over-limit fees are imposed by the creditor and payable by the person to whom credit is extended. But **they fall into a loophole** that's handy for the credit card companies and irritating for consumers. The loophole is part of Regulation Z, which was created by the Federal Reserve Board (FRB) as part of its efforts to make TILA practical in daily business.

Regulation Z defines finance charge, and it excludes "charges for actual unanticipated late payment, for exceeding a credit limit, or for delinquency, default, or a similar occurrence."

In Pfennig's case, the United States Court of Appeals for the Sixth Circuit agreed that the over-limit fee clearly was a finance charge.

Another way consumers sometimes get stuck with over-limit fees is by transferring a balance when they open a new account. In this case, the credit card company provides a lower limit than the consumer expected—while still transferring as much of the balance from another card as possible.

COMPARING NUMEROUS CARDS

If you don't want to much legwork to identify a good credit card, you can simply visit the Federal Reserve System's site at **www.federalreserve.gov**.

Every six months, the Fed surveys the terms of a host of credit card plans, then publishes a report of the findings, which are available on-line.

While this is a reputable report, you still will want to contact the credit card issuers directly to confirm that all the information is current and to learn about other credit card plans available.

CREDIT CARD SCAMS

While there are many reputable providers of credit cards, there are also many scam artists swimming in these waters. The crooks prey on consumers with

credit problems by making an offer that, if you think about it, sounds too good to be true. The magic words that so many rip-off artists use are: "You have been approved for a credit card. You cannot be turned down."

This sounds similar to the "pre-approved offers" reputable credit card issuers send out. But companies on the up-and-up will tell you that they're going to check your credit history before offering you a card.

Most credit card providers do not check your credit until they get your application. That's one reason children sometimes get "pre-approved" offers for credit cards in the mail.

Because they don't run your credit until they receive your application, legitimate credit card issuers absolutely do reserve **the right to turn you down after you apply.**

> **When someone promises that you absolutely will get a credit card, no matter how awful your credit history may be, beware.**

In one case, prosecuted by the Federal Trade Commission (FTC) in 2002, consumers received a solicitation in the mail very much along these lines.

The direct mail piece carried the title "Credit Approval Notification," and it went on to promise that readers had been approved for a $4,000 line of

credit. All they had to do was call a toll-free number to activate their credit cards.

Once they called, they were told that there was an advance fee of $199.95 to activate the card. Since these consumers were **eager to get credit**—and $199 can sound like a small price to pay for access to $4,000 worth of purchasing power—many paid the fee, believing that they'd get a Visa or MasterCard as soon as they paid it.

They didn't. Instead, they got a packet in the mail that included **a "merchandise card" and a catalog**. The card was good only on purchases from the catalog, which was filled with "high-priced, low-quality merchandise."

> The people were told that, if they spent a certain amount of money on catalog purchases and paid according to a certain schedule, they'd receive a Visa or MasterCard. Those who went along with the program eventually did receive a credit card, but it wasn't the unsecured card with a $4,000 limit that they expected. Instead, it was a secured card with a credit limit of just $240.

Those who tried to back out of the program met with all kinds of ploys designed to keep them from getting any money back.

Besides watching out for promises that "you cannot be refused," another tip-off that you may have received a fraudulent offer is the use of the phrase

"premier consumer credit card." Also keep an eye out for the image of an **unfamiliar credit card logo**, like the CashPlus logo used by one scammer, which was shown alongside the well-known Visa and MasterCard logos. Both of these techniques have been used by "merchandise card" scammers.

In another common ploy, you receive a mailing that says you're guaranteed to receive an unsecured credit card, regardless of your credit history—even if you've had a bankruptcy.

When you make the call, the telemarketer says you can get a credit card, as long as you have a valid bank account. Once you provide your bank account number, the company debits your account electronically—once, twice, maybe three times.

Also, beware of offers that require you to call a 900 number. You're paying for that call—and may end up paying several hundred dollars to receive a list of credit card issuers that you can get for free from a credit counseling service or on the Internet.

SECURED CREDIT CARDS

If you do have credit problems, there is a way to get a legitimate credit card and start rebuilding your credit. It's known as a **"secured credit card."**

Like a loan on a house or car, these cards are considered "secured" because you provide some collateral. In this case, it's in the form of a **security deposit**.

Basically, you send the credit card company a check, and the company sends you a credit card with a limit based on the amount you deposit.

The credit limit usually is from one to three times the amount of the security deposit—so you might provide a $99 security deposit to secure a card with a $200 limit.

> **The bank usually puts the security deposit in a savings account. When choosing a secured credit card, make sure your money will be placed into a savings account that will earn interest.**

Sometimes, after you've built up a good relationship with the credit card provider, **the security deposit will be returned** to you, along with any interest it earned.

Don't rush into a secured credit card. The cards usually require application and processing fees and come with a higher interest rates than unsecured cards. But many issuers, including the biggest names in the industry, offer secured cards. **Comparison shopping can save you a bundle.**

These cards clearly are not the best deal available, but they are a good first step toward rebuilding your credit. Your goal should be to **step up eventually to an unsecured credit card** with better terms and a higher credit limit.

CONCLUSION

Issuing credit cards can be a profitable business for banks and other outfits—that's why the marketplace is so crowded with brochures screaming about great offers. If you **take your time and review these offers**, you can find some good deals.

> **Know, from the start, that almost all issuers—including big, legitimate ones—hide fees and high interest rates in the small print of their disclosure forms and agreements. Take the time to read these.**

Frankly, some credit card issuers **play sleazy games** when it comes to telling consumers about conditions, terms and rates. In 2001, the Office of the Comptroller of the Currency settled case against the First National Bank of Marin (based, oddly, in Las Vegas), involving **misleading and deceptive marketing** of secured credit cards. The OCC said:

> *First National Bank of Marin markets to consumers with poor or nonexistent credit histories. Many credit card lenders, as a matter of prudent underwriting, will require such consumers to maintain a savings account large enough to secure the line of credit. Under the bank's program, the funds for the savings deposit are instead charged against the credit line, reducing the amount of available credit until the charge is paid off.*

In one of Marin's programs, applicants had to pay $79 to apply. The resulting card had a credit limit

of \$250 to \$600—but was secured by a savings deposit of \$200. Because that amount was charged against the card, along with another \$56 in fees, some cardholders *started out* over their limits.

That clearly defeats the purpose of having or carrying a credit card.

USING A CREDIT
CARD WISELY

Using a credit card wisely means planning **when and where** you'll use it.

More than anything, **avoid using your card for impulse purchases**. These images fill credit card ads on TV and elsewhere; but a spontaneous Christmas gift shopping spree is the worst use of a credit.

> **Another good thing to avoid is...anything your card issuer tries to sell you. Credit card companies work hard to offer all kinds of products and services to extract money from their customers.**

Take credit card **theft insurance**, for example. You don't need this. If your card is stolen, you're only liable for a maximum of $50 worth of purchases.

Credit card **disability insurance** is another loser product. If you can actually get your credit card company to activate the insurance in the event you become disabled (and it's not easy, typically), your

debt still keeps piling up. Plus, your credit card becomes disabled right along with you; you can't make any additional charges on it.

Prepaid gift credit cards can be another money-loser. In this case, the fees you pay make them worth less than what you paid for them. And they often expire quickly, which means the recipients may not even have a chance to use them.

You're usually better off giving cash, a check or gift card from a retailer, since those cards typically do not have expiration dates or hidden fees.

> Generally, it's not a good idea to use a credit card for buying gifts of any sort. Buy gifts with cash (or cash equivalents, like checks or debit cards). This may sound slightly Scrooge-like; but borrowing money to buy things you're giving away doesn't make much financial sense.

And, speaking of **hidden fees**, you should think twice before using your credit card abroad. It saves you having to exchange currency; but some Visa and MasterCard issuers have started charging a 2 percent **fee on credit card purchases outside the United States**—on top of the 1 percent charged as a currency exchange fee.

Those fees can add up, especially on a longer vacation. So, make sure that you carry **cash equivalents** like debit cards or traveller's checks if you're planning to go abroad.

DEBIT CARDS

We've mentioned **debit cards** in several places—and will in several more, later. So, these cards are worth a mention here. They can play a role in the smart use of credit cards.

Beginning in the 1990s, Visa and MasterCard convinced most banks to "co-brand" their ATM cards as debit cards carrying either the Visa or MasterCard logo and a similar account number. This arrangement meant that ATM cards could be used at bank cash machines and **like general-purpose credit cards** at stores, hotels and restaurants.

Debit card sales aren't credit sales, though. Essentially, the sales are like electronic checks—they result in a direct debit from the savings or checking accounts to which the cards are connected.

> When debit cards first came into wide use, some financial experts warned that they posed bigger risks than traditional credit cards. In some cases, banks didn't apply a credit card's $50 liability limit to debit cards that were stolen or used fraudulently. But more recent banking industry practices and government regulations have extended the $50 limit to debit cards.

Many banks **don't require a particular credit score** for a debit card; they issue the cards automatically to anyone who opens a new account. Others are more demanding, requiring a credit check or a mini-

mum balance in order to issue a debit card; still others will issue a debit card after an account has been with the bank for six months or a year.

From a financial perspective, debit card charges are better than credit card charges because they **don't generate interest** charges. And the cards aren't susceptible to late fees, over-limit fees and other charges that can make a credit card expensive to use.

Of course, a debit card can cause problems in a checking or savings account. It's possible to **overdraft an account** with too many debit charges...and some people find it more difficult to keep track of debit charges than checks or cash withdrawals. But, if you use a debit carefully, it can be a very convenient way to buy things.

And, because your spending limit on a debit card is set by the available cash in your accounts, you may find that the debit card comes with a built-in discipline that a credit card doesn't.

There are some merchants that don't accept debit cards. Most notably, the major U.S. rental car chains insist that renter's have "true" credit cards. But this is an exception—most places accept debit and credit cards interchangeably.

For all of these reasons, it makes sense to use a debit card (or cards) as your **first tools for daily purchases**. This allows you to save your true credit cards for big purchases, emergencies and rental cars.

BALANCE TRANSFERS

Credit card companies promote balance transfers heavily in their advertising and direct-marketing offers. As we've warned elsewhere in this book, **transferring credit card balances is not the same thing as paying off credit card debt**—even though card companies use terms like "pay off your other cards" in their promotions.

But a well-timed balance transfer can reduce your money payments, in some cases substantially. So the process is worth some mention.

The key to a smart transfer is doing your home-work. You may even want to create a chart like the one below to compare deals. We put together this example, assuming that you'll pay on time each month and maintain a constant balance of $2,000.

Terms	Credit Card 1	Credit Card 2
Debt balance	$2,000	$2,000
APR	6.99%	12.99%
Finance charges in a year	$140	$260
Annual fee	$0	$25
Total cost	$140	$285

By switching your $2,000 balance from Credit Card 2 to Credit Card 1, you can save $145 over the course of a year. A larger balance would mean an even more dramatic difference.

But several other factors, like **late fees and penalty interest rates** (if any), can throw a wrench into the works. If Card 2 is more forgiving than Card 1, and if you're likely to be late on a payment or two, then you may be better off staying put.

Also, some credit card issuers will transfer your balance for free, but many will charge you for the privilege. **Balance transfer fees** can be as much as 3 percent of the amount being transferred, although some card providers cap their fees at $35 or $50 per balance transfer. Still, by the time you've paid the transfer fees, the money you'll save in interest may be negligible—or nonexistent.

If you have good credit, you might want to consider an alternative to a balance transfer. Instead, you may be able to **renegotiate the interest rate** with your current credit card issuer. Credit card companies like to hang onto their good customers, and they often will lower the APR—or waive your annual fee, or increase your credit limit—if you simply call customer service and ask.

If you do jump ship, be careful when you transfer that balance. Sometimes, a balance transfer done by phone or via a balance transfer form can take as long as four weeks to go through. This most likely will make you late with the payment on your old card, if you didn't mail in a payment separately.

One way to avoid the risk of delays is to use a "convenience check" from the new credit card company

to make the transfer. That way, you can mail it in on time as if it were your regular monthly payment.

Once your balance has been transferred to the lower-interest card, your minimum monthly payment will be lower. But **try not to spend the savings**. One good idea is to keep paying the monthly minimum you were making on the more-expensive card. This will help you pay down your debt—which hasn't really changed.

SURPRISE BALANCE TRANSFERS

Some of the "pre-approved" credit card offers that come in the mail have an unhappy side effect. Sometimes, the fine print reveals that if you accept the offer, **you must transfer your balance** from a card you already have to this new card.

And if you read the rest of the fine print, you'll find that the new card just so happens to have a higher interest rate than your current card.

> **Because this information is spelled out in the offer, the automatic balance transfer is legal and you'll have little recourse if you fall for it. Consider it yet another reason to grab that magnifying glass before you accept any offer.**

A variation on this scheme: Some credit card issuers buy old debts from other consumer lenders and then offer "new" cards to the people in debt. If those

people say *yes* to the new cards, they're surprised to find, on the first statement, a balance that includes the old debt.

> Again, these deals are usually explained in the fine print on the back of the application for the new card. Look for phrases like "reaffirmation of existing debt," "automatic transfer of other balances" or "authorization to the transfer balances" in the application for *any* credit card. If you see this language, think twice before mailing it.

Also, beware of telemarketers offering to transfer your credit card balance to a new card with a wonderfully low interest rate. Some **identity thieves** use this technique to get their hands on your credit card information and other personal data.

If someone calls with a really tempting offer, ask to have it mailed to you. Genuine credit card issuers understand consumers' reluctance to give out personal information over the phone. If a caller is pressuring you, insisting that an offer is only available over the phone, consider that caller a scam artist.

CHANGING TERMS

Virtually all credit card agreements contain language that enables the card issuer to change the terms of your agreement at any time. So a credit card with a low interest rate could have a much higher rate down the road, even if it's supposed to be a fixed-

rate card. Likewise, a credit card with a long grace period can have a much shorter grace period at some point, the annual fee can rise, etc.

> To keep tabs on what your credit card issuer is doing with your account, read the fine print on the filler material that comes with your monthly credit card statement.

If you don't like what you read, there's little you can do about these changes. As the California Court of Appeal wrote in one case:

> *The {card issuer}'s position is...based on the premise that a credit card holder is always in a financial position to be able to immediately pay off the entire balance when confronted with an unacceptable change of terms. In fact, it is much more likely the reverse is true, and credit card issuers must be aware of that. So...the practical result is the consumer has no choice at all and is forced to "agree" to the modification.*

In this case, the credit card company—Household Finance—tried to change **cardholders' recourse in the event of disputes**. The initial agreement, which James Shea had received in 1993, said disputes would be resolved in Illinois under federal law. Six years later, Household sent Shea a notice that the "choice of law clause" was being changed to Nevada. Later, it notified him that his account would require that "any claim, dispute or controversy" be resolved through binding arbitration.

Shea tried to opt out of the arbitration clause. He contacted the card issuer's customer service department to inform it that he "was refusing to accept the arbitration agreement being unilaterally imposed...and that [he] no longer wished to continue using his account."

Then he filed a lawsuit, which required the court to determine whether he was bound to use arbitration. The California Court of Appeal ruled:

> ...enforcement of the provision would also fly in the face of California public policy. {Shea} could not escape from the confines of arbitration. The amendment states: "This arbitration agreement shall survive termination of your Account as well as the repayment of all amounts borrowed hereunder." Even if {Shea} had done what {the card issuer} suggests, he still would have been subject to the arbitration provision; there was no way for him to opt out. ...a good case could be made the term was unconscionable.

It's a good idea to avoid cards that require you to settle disputes through arbitration. If you do wind up having a grievance, you'll have to pay your own attorney's fees through the arbitration process.

READ YOUR STATEMENT. REALLY

When you get your credit card bill each month, read the statement carefully. You should:

- check the amounts of each listed transaction against your card receipts;

- spot any charges you did not make;

- study the fees; and

- note any unjustified fees.

If you haven't already, set up a regular place—your briefcase, a folder in the den, the sock drawer of your bureau…any place—where you put your credit card receipts when you get back from traveling, shopping or going out. Then, schedule a regular hour or two each month when you open your credit card statements and connect each receipt to each posted item (and read the small print at the bottom or on the back of each statement).

> **You'd be amazed how many times consumers' credit cards are charged for things they didn't authorize.**

In 2002, Citibank settled a lawsuit with 27 states and Puerto Rico because of the **deceptive telemarketing techniques** employed by one of Citibank's marketing partners. Among the problems: Citibank customers were being billed for products they hadn't ordered. Providian Bank—another big card issuer—has also faced the same charges. In 2000, the Comptroller of the Currency noted:

> *…Providian engaged in a variety of unfair and deceptive practices that enriched the bank while harming literally hundreds of thousands of its customers. …we have entered into a consent order with the bank that ensures not only that these practices will come to an end, but that customers who were harmed will be compensated by Providian.*

> *The order provides that the bank will pay at least $300 million in restitution to its customers. ...Consumers should not have to become detectives to find out the true terms and conditions of their credit card agreement. They should not discover after they receive their monthly statement that they have purchased a $156 credit protection policy that they neither want nor need. And if they are promised a promotional bonus for transferring credit balances, they should receive that bonus—and not be told after the fact that the program requires a balance transfer of $10,000...*

Credit card issuers have been known to **tack on some tricky "extra" fees**, as well. In 2002, First USA Bank paid $39.9 million to settle a lawsuit alleging it had charged bogus finance charges and late fees.

In addition to studying the finance charges and any late fees, keep a lookout for an **annual fee**—especially if you selected a card that isn't supposed to charge one.

Fleet Bank got nailed in 2002 under the **Truth in Lending Act** for charging an annual fee after its initial solicitation promised a card that was fee-free. The appeals court wrote:

> *A statement...that a card has "no annual fee" made by a creditor that intends to impose such a fee shortly thereafter, is misleading. ...Fleet's proposed approach would permit the use of required disclosures—intended to protect consumers from hidden costs—to intentionally deceive customers as to the costs of credit.*

WHAT TO DO ABOUT ERRORS

If you have errors on your credit card statement, you have recourse. Under the **Fair Credit Billing Act** (FCBA), there are specific steps you can take to correct your account.

What kinds of errors are covered? According to the Federal Trade Commission, the FCBA covers such billing errors as:

- **unauthorized charges** (federal law limits your responsibility for unauthorized charges to $50);

- charges that list the **wrong date or amount**;

- charges for purchases you didn't accept or that **weren't delivered** as agreed;

- **math errors**;

- failure to post payments and other credits, such as returns;

- failure to send bills to **your current address** (as long as the credit card provider received your change of address, in writing, at least 20 days before the end of the billing period); and

- charges for which you ask for an explanation or **written proof of purchase** along with a claimed error or request for clarification.

If you discover an error, you should take advantage of the law's consumer protections. This means you must **follow a set process**:

1. Write to the credit card company at the address shown on your bill for "billing inquiries," which most likely is different from the payment address.

2. In your letter, include your name, address, account number and a description of the billing error.

3. Include copies (not the originals) of any sales receipts or other documentation that supports your position. Also, be sure to keep a copy of the dispute letter.

4. Mail your letter so that it reaches the credit card company within 60 days after the bill that first contained the error was mailed to you.

5. Send your letter by certified mail and get a return receipt, so you have proof that you mailed it, as well as proof that the credit card company received it.

The credit card company **has to acknowledge your complaint** in writing within 30 days of receiving your letter, unless the problem has already been cleared up.

And the company also must act quickly. The FCBA allows only **two billing cycles**—or not more than 90 days since receiving your letter—for the company to resolve your dispute.

While the dispute is being resolved, you do not have to pay for the amount in question, and it cannot be reported to credit agencies as delinquent.

> **The credit card company can report that you have disputed your bill, and the company also can applied the amount in dispute toward your credit limit.**

If the credit card issuer caused the error, it must **provide an explanation** to you in writing. It also has to credit your account and remove any late fees or other penalties related to the billing error.

If the company determines that **the bill was correct** and you were in error, you must again be notified in writing. Then you must pay the amount, as well as any finance charges accrued. You also may have to pay the difference between the minimum amount you did pay during the dispute and the amount you otherwise would have had to pay.

If you still believe the creditor is wrong, you have to act fast. You have only **10 days to reply** to the credit card company's letter. And here's where your protection starts to drop off.

> **You may tell the credit card company that you refuse to pay the disputed amount, but now the company is allowed to begin collection procedures.**

The company can report your account as delinquent to the credit bureaus, although it has to notify them that you believe you don't owe the money. Plus, it has to tell you who received these reports.

If you are in the middle of disputing a charge—or if you have a questionable charge on your bill—you'll need to **refrain from transferring** the balance on the credit card. If you transfer the balance, you may lose the right to dispute previous charges.

CONCLUSION

Most of the best tips for using a credit card wisely are just common sense. And, really, they all boil down to two basic points:

- don't use a credit card for impulse purchases; and

- read your statement every month.

The second point is the one that trips up most people. It's surely easier to pay the balance or minimum—or some amount in between—and move on to more interesting things.

But keep in mind that **errors are fairly common** on credit card statements. Even if you don't have all of your credit card receipts handy, compare as many as you have to the items listed in your statement to make sure the dates and amounts are right.

Also, credit card issuers are heavily regulated. They have to publish the changes they're making to your account...and **they do this in the fine print** at the bottom or on the back of the monthly statement. Most count on people not reading these notices.

Don't be that person.

CHAPTER **6**

DEALING WITH
CREDIT BUREAUS

The best way to get and keep a good credit score is to earn a steady income, borrow some—but not too much—and pay all of your bills on time. And don't get sued by anybody. And do all this consistently, over your whole adult life.

Not everyone manages the credit equation perfectly. In fact, **most people have problems** with some part of it at some point. If you're one of those many, you'll need to **manage your credit score**—especially if you want to buy or refinance a house, get a new car or start a business.

> **Credit scores are designed to be hard to change, though. They are part of a decentralized system: one group of companies keeps your financial data, another group analyzes it and a third uses the analysis to make lending decisions.**

The best way to improve your credit score is to know and manage your financial data, which is kept by

credit bureaus. (These companies are more formally called "consumer reporting agencies" or CRAs.)

Financial counsellors usually recommend getting a copy of all three of your credit reports **three to six months before** you apply for a home loan, buy a car or attempt to borrow a large sum of money for any other reason. Even if you aren't planning a major purchase, most experts suggest that you check your credit reports once a year.

You should check them more frequently if you're cleaning up your credit history, or if you've been a victim of fraud or identity theft.

HOW TO GET YOUR REPORTS

There are companies that would be delighted to sell you access to your credit reports for a nice chunk of change, often $99 a year. But you can save most of that money by **contacting each credit bureau directly**.

In late 2003, the U.S. Congress passed the **Fair and Accurate Credit Transactions Act** (FACT Act). It gives consumers the right to receive a free annual credit report on request—and it also contains a number of provisions that were designed to improve the accuracy of credit reports.

If you're on the West Coast, you will be able to receive a free credit report from all three major credit bureaus beginning in December 2004. The pro-

gram will roll out across the country, finishing on the East Coast in September 2005.

In the interim, you still may qualify for a **free copy of your credit report**. Under earlier legislation, you are entitled to one free copy of your report during any 12-month period if you have been:

- denied credit for any reason;

- a victim of fraud;

- unemployed and you plan to look for a job within 60 days; or

- on welfare.

Whatever your reason, the best way to get your hands on your credit history is to contact each credit bureau directly. You can reach them at:

Equifax Credit Information Services Inc.
P.O. Box 740241
Atlanta, GA 30374
1.800.685.1111
www.equifax.com

Experian (formerly TRW)
1.888.EXPERIAN (1.888.397.3742)
www.experian.com

TransUnion Corp.
760 W. Sproul Rd.
Springfield, PA 19064-0390
1.800.916.8800
www.transunion.com

Sometimes, only one or two of the credit bureaus will have a report on you. But, to be sure where you stand, it's in your best interest to **contact all three**. You can access your credit report on-line at each bureau's Internet site, or have it mailed to you.

DIFFERENT KINDS OF REPORTS

In case you're thinking, "Hey, I have a friend at a bank or mortgage brokerage who can pull my credit report for me," think again. While it would be lovely to get your report for free, the reports sent to consumers are different from the ones sent to businesses.

You want the report designed for consumers because it's much easier to read, with the names and contact numbers for businesses spelled out (rather than listed by numerical code).

The consumer version contains information on companies that have accessed your credit report for promotional purposes, such as pre-approved credit card offers, while the business-to-business version does not.

ADD-ON SERVICES

The FACT Act changes the dynamics of how credit bureaus interact with consumers. You can get free reports more easily, but credit bureaus push more extensive—and expensive—**reports and programs**, including ongoing credit-report monitoring.

CRAs would like to sell you services that include reports from all three major credit bureaus. Equifax charges $29.95 for it. Trans Union charges the same and throws in a credit score and a personalized analysis with "tips for making your score higher." And Experian offers a three-bureau credit report, plus a credit score, for $34.95.

Experian also would like to sell you *Credit Manager* for $9.95 a month. This gives you access to your credit report and credit score, as well as e-mail notification of any changes to your credit report and access to a host of tools that may or may not be useful. These tools include a **credit score simulator** to see how different factors may affect your score.

Trans Union and Equifax offer similar programs. Each has some unique twists to its offerings. However, unless you are dealing with fraud or identity theft—or trying to clean up your credit history as quickly as possible—odds are that **a simple credit report** will meet your needs.

If you would like to get your FICO score, you also can get it directly from **Fair, Isaac & Co.** It currently is available on-line only, at www.myfico.com. The company charges $12.95 for your FICO score plus one credit report from any of the three CRAs.

You also may want to visit myfico.com to access the free **FICO Score Simulator**. It analyzes your personal credit information and answers questions like, "What happens to my score if I pay off a credit card or open a new account?"

NOBODY'S PERFECT

If your life is sailing smoothly and you've never been turned down for credit, you may think you have no reason to check your credit report. But, even if you're doing fine, **your report may contain errors**.

In June 2004, U.S. PIRG, the national lobbying office for state Public Interest Research Groups, released a survey that stated, "**One in four credit reports contains errors** serious enough to cause consumers to be denied credit, a loan, an apartment or home loan or even a job."

And other experts point out that nearly every American will find an error on at least one of his or her credit reports.

According to the U.S. PIRG survey:

- 25 percent of the credit reports contained errors serious enough to result in the **denial of credit**;

- 79 percent of the credit reports contained **mistakes of some kind**;

- 54 percent of the credit reports contained **personal identifying information** that was misspelled, long-outdated, belonged to a stranger, or was otherwise **incorrect**; and

- 30 percent of the credit reports contained credit accounts that had been closed by the consumer but **incorrectly remained listed as open**.

Errors wind up on your credit report simply because the consumer reporting agencies collect information from all kinds of creditors, but they don't verify that information.

According to Fair, Isaac & Co., the most common mistakes on credit reports happen because:

- people apply for credit under different names (for example, Robert Allen and Bob Allen);

- the person who input the information had trouble reading a handwritten application;

- someone made a typo or other clerical error while inputting the information;

- someone provided an inaccurate Social Security number; or

- payments were posted to the wrong account, accidentally.

The only person who will verify the accuracy of your credit reports is you.

FIXING MISTAKES

So, you check your credit reports and find a few mistakes. What do you do next?

You can **dispute inaccurate information** with a CRA. If you tell a CRA that your file contains inaccurate information, the CRA must investigate the

items—usually within 30 days—by presenting to its information source all relevant evidence you submit. After that, the Fair Credit Reporting Act sets the rules for how corrections are made:

- The source must review your evidence and report its findings to the CRA. It also must advise other CRAs of any error. The CRA must give you a **written report of the investigation** and a copy of your report if the investigation results in any change.

- Inaccurate information must be **corrected or deleted**. A CRA must remove or correct inaccurate or unverified information from its files, usually within 30 days after you dispute it. However, the CRA is not required to remove accurate data from your file unless it is outdated or cannot be verified.

- If the CRA's investigation does not resolve the dispute, you may add a **brief statement** to your file. The CRA must normally include a summary of your statement in future reports.

- You can dispute inaccurate items with the **source of the information**. If you tell anyone—such as a creditor who reports to a CRA—that you dispute an item, they may not then report the information to a CRA without including a notice of your dispute.

Outdated information may not be reported. In most cases, a CRA may not report negative information

that is more than **seven years old** or 10 years for bankruptcies.

If you have a problem with a credit report, it's virtually impossible to contact anyone at Equifax, Experian or TransUnion directly. The best you can usually manage is to leave a telephone message or fax a letter to a generic recipient.

SPECIFIC STEPS TO TAKE

- Start off by **making a copy** of your credit report. Keep the original in a file that eventually will contain all of the documentation regarding the error.

- On the copy of your report, **mark the error. Send this** to the credit bureau, along with the dispute form that you should have received with your report. If you don't have the dispute form or don't want to use it, it is always acceptable to send a letter instead.

- In addition to the letter and the copy of the credit report, you'll also need to **send documentation** that supports your claim that the item is wrong.

- If you don't already have documentation to support your claim, you will want to **contact the creditor** that submitted the information first. For instance, if a loan shows up as outstanding and it has been paid off, get a letter from the lender stating the correct information.

- Send your letter, the copy of the report and documentation via **certified mail with a return receipt**, so you have proof that you mailed these items and that the credit bureau received them.

- Be sure to keep a copy of your letter and/or the dispute form, as well as anything else you send to the credit bureau. And **keep everything** you receive from the bureau, as well.

- If you speak with someone at the credit bureau by phone, take notes and make sure to **get the person's name**. Also note the date and time of your call.

By law, the CRA has to investigate your dispute **within 30 days of receiving your letter**. (The exception would be if the CRA decides that your claim is "frivolous" or "irrelevant.")

Any item that the CRA cannot verify as accurate must be removed from your credit report.

If the credit bureau makes a change to your report, the company must send you a revised version.

The CRA cannot put the information back on your credit report unless the creditor in question later verifies the accuracy of the information. If this does happen, the CRA has to notify you that the info is back on your report.

BEWARE OF ID THIEVES

One reason we recommend contacting the credit bureaus directly to receive copies of your credit reports is because there are numerous scam artists on the loose who are "**phishing**" or "**carding**"—in plain English, looking for credit card information.

One way they do this is by setting up Internet Web sites. There, the scam artists offer **cheap or free access to your credit reports** as a way to lure you into giving them your information.

What are they phishing for? Anything that can help them pretend to be you. They want your:

- credit card numbers;
- bank account information
- Social Security number;
- passwords; and
- other sensitive information.

ID thieves are happy when they get several of these items at once. When they have enough pieces of information, they create an alternate version of you to apply for credit and commit other frauds.

If you've received an offer to provide inexpensive credit reports or credit repair services, the Federal Trade Commission offers the following tips to avoid getting scammed:

- Contact the company by phone or go to the Internet site directly, rather than clicking on a link in an e-mail.

- Check the sender's e-mail address. If it looks unusual or if it ends in .ru or .de instead of .com, be suspicious.

- Determine if the company has a working telephone number and a legitimate street address. Such Internet sites as www.switchboard.com will enable you to find the company's address, and reverse lookup search engines like www.anywho.com will help you with phone numbers.

- Check the e-mail and Internet site for spelling errors and bad grammar, as well as other mistakes, like a telephone area code and an address that don't match. These often are a tip-off that something's not right.

- Double check the Internet site address to ensure it's the correct spelling of a company. Some scammers create sites with names that are just a little off.

- Rather than just clicking a link, use the URL that's part of the sender's address (for joe@example.com, go to www.example.com). If it redirects you to a different site, don't go any further.

- Visit www.networksolutions.com or one of the other domain name providers and do a "Whois" search to find out who owns the site in question.

- Immediately leave any Web site that asks for personal information that's not relevant to your credit report, such as a

personal identification number (PIN) for your bank account, the three-digit code on the back of your credit card or your passport number.

- Make sure the site is secure. Look for the little lock icon on your browser's status bar, as well as "https" as the start of the site address on any pages where you need to fill out a form. Most URLs start with "http"; the "s" tells you the site is secure.

If you encounter any suspicious activity, have any unauthorized charges on your credit card or never receive the credit report you requested, you'll want to contact the FTC at **www.ftc.gov** and contact the U.S. Secret Service.

You'll find the local Secret Service office listed in your phone book.

IF ERRORS AREN'T FIXED

The process to fix errors on your credit report sometimes can be long and frustrating. And it is possible that you will need to apply for credit before all of the errors are resolved.

In this case, you'll want to provide copies of your **correspondence with the credit bureaus** and supporting documentation along with your application for credit. Be as thorough as possible; most of the time, lenders won't be convinced by your documents unless they are detailed and clear. You have a lot of skepticism to overcome.

CONCLUSION

Many people make the mistake of assuming that **credit bureaus exist to serve individual consumers**—and get frustrated with the lack of responsiveness and customer service that the credit bureaus have traditionally offered.

> **If you remember that you're not the credit bureau's primary customer, you may understand the cool reception the credit bureaus give you.**

The problem with this approach to the handling of credit information is that it accepts a **higher level of inefficiency** than most consumers would like. In this way, the credit industry is something like the health insurance industry—in both cases, the primary customers (lenders, in the case of credit bureaus; employers, in the case of health insurance) are not the end-users of the services being sold.

An economist looking at this system would likely conclude that it's not intended for efficiency, if efficiency means timely and accurate exchange with the greatest number of users. Industry insiders claim that **the inefficiency makes credit information hard to manipulate** and—in theory—more reliable. For lenders.

WHO CAN LOOK AT
YOUR CREDIT

You might think that your credit report is confidential. Yet, while the information contained therein is pretty darn personal, it's **by no means a secret**.

A variety of people or companies can look at your credit report, as long as they have a "permissible purpose," as defined by the **Fair Credit Reporting Act**. This variety includes:

- potential lenders;

- credit card issuers;

- potential landlords;

- banks (e.g., when considering offering you overdraft protection or while setting your ATM cash withdrawal limit);

- insurance companies;

- employers and potential employers (though only with your written consent, in most cases);

- government agencies (although they may only view portions of your report);

- a company you hire to alert you to signs of identity theft;

- some groups considering your application for a government license or benefit;

- someone who needs to access your report in order to provide a product or service you ordered;

- a state or local child support enforcement agency; and

- anyone else who has your written permission to access your credit report.

You'll notice that most of the people on this list are people with whom you have **initiated business** of some sort, whether you applied for a loan or hired a company to prevent identity theft.

Other groups require your written permission before they may view your credit history, including employers and potential employers.

POTENTIAL EMPLOYERS

Why would employers want to view your credit report?

Perhaps you've applied for a job at a bank or someplace else where you will be **handling money**. Perhaps you've applied for a high-security job, where you will have access to **valuable information**. Or perhaps you're going to be working with other valuables—such as jewelry, stock certificates or bonds.

In all of these cases, the employer or potential employer wants to be certain that you are responsible, not desperate for money. After all, if you're desperate and you're surrounded by temptation, you might take advantage of the situation.

> **Employers and potential employers do receive a different version of your credit report than the one that goes to potential lenders. It's usually less detailed, with regard to credit account histories; and it doesn't count as an inquiry on your credit score.**

INSURANCE COMPANIES

Some potential employers may have a reasonable need to check out your credit history, but insurance companies? **Where is their need?**

As it turns out, your credit rating and your driving record probably are completely unrelated. But auto insurers have found that your likelihood to pay your credit card bills is closely related to your likelihood to pay your insurance premiums.

The same holds true for other types of insurance, too, including life insurance.

However, many states are looking unfavorably on insurers' use of credit histories in underwriting. Washington, Utah, Idaho and Maryland have already passed laws restricting insurance companies' ability to do so, and many more states soon may follow suit.

LENDER INQUIRIES

Throughout this book, we recommend that you shop around for credit—a new credit card, a home loan or an auto loan.

But *how* you shop around **can affect your credit rating**.

The issue is whether or not a potential lender or credit card provider requests ("pulls" in industry jargon) your credit report.

Every time one of these companies pulls your credit report, it counts as a **"hard" inquiry**. And hard inquiries **lower your credit score**.

One way to be sure you're getting information—and not having your credit report pinged at the same time—is to **withhold your Social Security number** until you're ready to make a decision on a lender or credit card company.

Unfortunately, this can be tricky—especially when you're shopping for credit on-line. Most on-line lenders require you to provide your Social Security number before they will quote an interest rate, since interest rates are closely tied to credit scores.

And when you provide this information, you are applying for credit—and that gives the lender your permission to check your credit report.

WHY INQUIRIES MATTER

New credit is one of the factors used to determine your credit score. In fact, new credit accounts for 10 percent of your credit score.

> **Hard inquiries are considered a subset of the new credit category.**

According to Fair, Isaac & Co., the information about inquiries that can be factored into your FICO score includes:

- the number of recently opened accounts that you have and the proportion of accounts that are recently opened compared with long-standing accounts, by type of account;

- the number of recent inquiries;

- the time since recent account openings, by type of account; and

- the time since you last had any credit inquiries.

As Fair, Isaac & Co. writes on its Web site:

For many people, one additional credit inquiry (voluntary and initiated by an application for credit) may not affect their FICO score at all. For others, one additional inquiry would take less than 5 points off their FICO score.

Inquiries can have a greater impact, however, if you have few accounts or a short credit history. Large numbers of inquiries also mean greater risk.

> According to Fair, Isaac, people with six inquiries or more on their credit reports are eight times more likely to declare bankruptcy than people with no inquiries on their reports.

AUTO LOANS & MORTGAGES

That said, the credit industry understands the importance of comparison shopping for auto loans and mortgages. In fact, most lenders want to **encourage shopping**—since it increases the chance that you'll give them a try. So, some changes to credit scoring models make in the 1990s and 2000s take into account the likelihood that a smart borrower may generate multiple inquiries along these lines.

> Under the FICO scoring model, it doesn't matter how many inquiries for an auto or home loan that you generate in a 14-day period. They all count as a single inquiry.

What's more, your score does not include any mortgage or auto loan **inquiries that were made in the 30 days prior** to scoring. So, you've essentially got 44 days to get your act together.

Once you've started filling out applications and generating inquiries, remember: The clock is ticking.

CREDIT CARD INQUIRIES

While credit scoring models will cut you some slack when you're comparison shopping for an auto or home loan, they are not so approving of multiple **inquiries from credit card issuers**.

One reason: You may have opened one or more credit card accounts within the last month or so, and they wouldn't appear on your credit report just yet.

And, not to say that *you* would do so, but some people open a lot of credit card accounts at one time when they're planning to run up a whole lot of debt—and not pay it back.

On this count, the credit bureau Experian echoes Fair, Isaac's conclusions:

> *The more inquiries that appear on a borrower's credit file, the more likely a borrower may not be able to pay his or her bills as agreed.*

Lenders are vague about **how many inquiries** in what period of time scare them away. But the consensus is that lenders look at credit card inquiries going back six months. If you have six or 10 inquiries in that time period, you could be considered high-risk—even if your score is good.

Inquiries that happened more than six months ago typically are not a concern, since lenders figure you would have opened the account by now, and it would show up on your credit report.

On the other hand, if you do open up several credit card accounts at about the same time, you can be sure you'll be throwing up some red flags.

INQUIRIES THAT DON'T HURT

So-called "soft" inquiries do appear on your credit report, but they do not affect your credit ratings.

Soft inquiries include:

- your own requests for your credit report;
- credit checks performed by companies that want to send you a marketing offer;
- inquiries made by lenders or other businesses with which you already have an account; and
- inquiries made by prospective employers.

Also, some middlemen—like credit counselors and loan brokers—may pull your credit. And they may allow several lenders to pull it, too. In most cases, these will all be considered soft inquiries.

PERMISSION V. PERMISSIBLE

People who access your credit ratings have to have your permission—unless they have a "permissible purpose" for viewing that information.

In other words, sometimes people have every right to pull your credit without your permission.

Take the case of Karen Wiegand and Steve Marzluff. Under the terms of their divorce settlement in 1994, she got to keep the house, and he was required to make child support payments to her.

In later discussions, they agreed that she would transfer her interest in the house to Marzluff, and he would pay her $6,000 and refinance the mortgage so that she was no longer a debtor on the property. She deeded the property to him in 1995. But he never refinanced. He also stopped making his child support payments in January 2000.

> Wiegand might never have known that she was still on the mortgage, if she hadn't applied for a loan on a new residence in February 2001. During the application process, she discovered that she was still indebted on the old property.

At the time, Wiegand worked for Verizon Wireless. As part of her job, she obtained credit approval for people who applied for cellular telephone service. Upset about her ex-husband's failure to hold up his end of the bargain, Wiegand used her company

laptop to check his credit score to see if it was good enough to have enabled him to refinance the house.

When she did, Verizon's computer system **automatically generated a letter** to Marzluff confirming his "application for cell phone service."

Marzluff hadn't applied for cell phone service, and he told that to Verizon. Verizon discovered Wiegand had obtained her ex-husband's credit score without his permission. This was against company policy; **she was promptly fired**.

Meanwhile, Marzluff decided to sue both his ex-wife and Verizon for a variety of things, including violation of the **Fair Credit Reporting Act** (FCRA) for checking his credit without his permission.

When the case went to appeal, the Montgomery County, Ohio court surprised Marzluff. It said his ex-wife did indeed have a "permissible purpose" for checking his credit. In this case, the court said that their relationship was not one of ex-husband and ex-wife, but one of debtor and creditor.

The court wrote:

> *Wiegand had at least some reason to believe that Marzluff owed her a debt and that he had failed to comply with the terms of their transaction. These facts are sufficient to create a permissible purpose under the FCRA....*

So the court determined that she—as an ex-spouse in the midst of a divorce—had the right to **check Marzluff's credit without his permission**.

SNEAKY PEEKS

Reputable lenders or loan brokers will ask you sign a document that gives them formal permission to pull your credit as part of a loan application process. If you sign such document, make sure that it states clearly *who* has permission.

Don't sign any document that gives a broker or potential lender open-ended permission to look. Most brokers should be able to pull one report and share their copy with potential lender; if your broker insists that he or she has to let different lenders pull your credit, only agree to give permission separately to each lender as they request.

Some potential lenders who don't yet have a permissible purpose to pull your credit may try tricks to get your permission without your understanding. Some will include slick language in their promotional brochures that states **any response** from you will constitute permission to pull your credit.

Again, your best protection in these cases is to withhold your Social Security number until you know more about the offer. And, again, this can make things difficult—especially for on-line credit applications. But the point is to withhold key information until you've signed a formal document giving permission to pull your credit. This will limit your exposure to surprises and abuse.

Telemarketers and on-line lenders can be especially slick about getting your permission. A telemarketer selling a credit card might say something about "getting you an **approval right here on the phone**, if you'd like that" and take your agreement as permission. Likewise, on-line lenders may offer "instant approval" **if you "confirm" information** or check a box.

Be wary of either pitch. The safest course for you is to **put everything in writing**—so, state clearly to the telemarketer that you're not going to give approval for anything unless it's in writing. And ask any on-line lender to contact you by telephone or e-mail to arrange a written permission.

CONCLUSION

Inquiries into your credit reports can hurt you in two ways: by lowering your credit score and by exposing you to ID theft and other abuse. Keeping all permissions in writing helps control these risks.

CHAPTER 8

RED FLAGS AND
BLACK MARKS

Generally, people are pretty good about paying their bills on time and managing their credit. According to the Internet Web site www.myfico.com:

- Fewer than 4 in 10 consumers have ever been reported as 30 or more days late on a payment.

- Only 2 in 10 have ever been 60 or more days overdue on a credit obligation.

- Fewer than 1 in 10 have had a credit account closed by the lender.

These promising numbers are balanced by other, more broadly-defined, analyses that suggest higher levels of consumer debt will eventually lead to **higher delinquency and default** numbers.

Through the 2000s, there has been steady unease among economists about these **higher debt levels** making credit problems a big issue. So, in this chapter, we'll consider the warning signs that lenders look for and what happens when people get behind in their credit accounts.

THE BASIC TROUBLE SIGNS

Banks, lenders and credit bureaus look primarily for **late payments or delinquencies** as a sign of financial trouble. In short, delinquencies are reports that lenders make to credit bureaus when a borrower falls 30 days or more past due on a scheduled payment for a credit account.

Delinquencies are measured in **30-day units**. If a credit card payment is due January 1 but you haven't made it within a few days of February 1, there's a fair chance that your credit card company will report a 30-day late notice to the major credit bureaus.

If you haven't made the payment by around March 1, the credit card company will almost certainly report a 60-day late notice to the bureaus. And, if you haven't made the payment by April 1, the company will report a 90-day late notice.

Lenders and credit bureaus also track payments that go later than 90 days. But most finance companies lump all seriously late payments in a "90-days-or-more" late category.

Delinquency notices are not the same thing as late notices lenders may send you or collection actions they may take. Delinquencies are separate communications between the lenders and the credit bureaus. They don't mean—necessarily—that an account is under review, suspended or in foreclosure.

A lender might report a 30-day late notice before you even realize you've fallen behind. For this reason, many credit card companies and consumer lenders are forgiving about reporting **an occasional 30-day late payment**. They'll assume that some simple mistake explains the delay.

However, if you go 60 days late on a payment or make 30-day late payments consistently over several months, you'll almost certainly have notices in your credit report.

Delinquencies might seem like small matters; but they're not. They stay on your credit report for years—even if you bring your payments current right away.

> **Delinquencies have a particularly bad cumulative effect. One 30-day late notice might not hurt your credit horribly; but three or four of them can lower your credit score a lot.**

Collection activities and charge-offs are the second category of trouble signs that lenders look for in a credit report. These are actions that you will (or should) know about, because lenders warn you in writing that they are going to take the actions.

In consumer credit lending, **collection activities** (or "going into collection") can mean the lender turns your account over to an in-house collections department or it turns the account over to an outside collection agency. For you, the outside collec-

tion agency is usually worse, meaning more letters and angry telephone calls. But, to your credit report, going into collection is bad—whether the collector is in-house or an outside agency.

A **charge-off** is a slightly worse version of going into collection. It means the lender has given up on collecting the debt and is writing off the amount from its active accounts. The lender retains the legal right to collect the debt but, at present, it's counting the debt as uncollectible.

> **A charge-off is to unsecured debt what a foreclosure or repossession is to secured financing. It's very bad for your credit—sometimes worse than a bankruptcy filing.**

Like delinquencies, collections or charge-offs stay on your credit report for seven years—even if you pay the amount owed in full. Still, if you can pay the amount in full, you should. Credit reports will show the collection or charge-of item as "paid" or "satisfied." That minimizes the damage somewhat.

Another trouble sign for lenders is a **maxed-out credit line** (or several). Even if these accounts are being paid in a timely manner, they raise a red flag and suggest that you may have money problems.

Most credit counsellors suggest moving debt around, if you've maxed out one or two credit lines. For example, if you have one maxed-out credit card and several others that haven't reached their credit lim-

its, you should move some of the debt from the maxed-out card to others.

However, moving debt around is not as good for your credit rating as **paying debt off**. If you have total unsecured debt that's more than 20 percent of your annual income, lenders may not want to give you the best deal on a loan—or loan to you at all.

Most lenders look for a pattern of payment rather than focusing on onetime or rare occurrences. So, consistent on-time bill payments will improve any blemishes and raise your credit score.

PROBLEMS WITH SECURED DEBTS

So far in this chapter, we've been talking about problems with nonsecured debts—money you owe credit card companies, department stores, student loan companies, etc. Nonsecured lenders are often more flexible about working with people who are having financial problems because they have to be (their loans are only as good as a borrower's ability to pay) and because they charge relatively high interest rates.

Secured lenders—who've loaned money that's backed by specific collateral—are **not always so flexible**. If you fall behind on the payments for a secured loan on a house, auto or boat, you're in danger of having the property seized by the lender.

In the case of real estate, that means **foreclosure**. In the case of a car, truck or boat, that means **re-**

possession. Foreclosures and repo's are the worst marks that you can have on your credit. You should do everything that you can to avoid them.

If you're having trouble making the payments on your home, contact the lender. The **sooner you say something, the better** the chance that the lender will work with you to avoid foreclosure.

Foreclosures cause almost as much trouble for the lender as they do for the borrower. Among other problems, a large number of foreclosures will call regulatory attention to a bank or lender. And no bank likes that kind of attention.

A mortgage lender may **reduce or even excuse** your payments for a short period of time. However, once you start making regular payments again, you probably will have to pay extra to cover the past-due amount.

Another possibility: The lender may **extend the repayment period** on your loan—basically, tacking missed payments onto the end of the schedule.

Either of these solutions will probably involve some form of **fee or penalty**; but these fees will usually be a bargain compared to the higher interest you'll have to pay on everything if you have a foreclosure on your credit report.

Many finance companies specialize in refinancing home loans for people who are having money prob-

lems. In these cases, you may end up paying a higher interest rate over a longer period of time—both bad ideas. But a refi can bring your loan current and "buy you time" to get past temporary problems. **As long as those problems _are_ temporary.**

If you can't work out a payment schedule with your lender or another finance company, you'll want to contact a housing counseling agency. You can find an agency through your local Department of Housing and Urban Development office (you can get a list of these on-line at **www.hud.gov**) or through your local city of county housing authority.

> **Depending on where you live and the value of your house, there may be a government program that can get you a short-term loan to make your payments or refinance your existing loan.**

As a last resort, **selling your home** usually is preferable to letting it go into foreclosure—at least from a credit score standpoint.

In some situations, though, you can't sell the house for enough to pay off your loans. If you're in this position, ask your current lender to refinance your loan to bring your payments current. Show the lender comparative sales of similar houses in your area and any other proof you have of what homes are fetching.

Emphasize that you want to **avoid foreclosure** and stay put until prices rise again.

> One critical note: Foreclosure doesn't mean that you automatically lose your house. In most cases, you can negotiate terms for "reinstatement" of your loan after the foreclosure process has begun.

With most lenders, **a different group of employees** manage foreclosure accounts. If your house really won't bring as much in a sale as you owe on it, the foreclosure staff may be more open to setting up a reinstatement program that will allow you to bring the loan current over a period of time.

> As with collections and charge-offs, a foreclosure that you get reinstated will still show up on your credit report for seven years. But it will show that the loan was reinstated which (like a paid charge-off) reduces the damage.

Of course, bringing a mortgage current or getting it reinstated out of foreclosure will require enough income to make timely payments. If you don't have that income and the house won't sell for what you owe, you may have **little choice but to "walk away."** That means allowing foreclosure to proceed and moving out before the lender evicts you.

Some credit counsellors suggest walking away from a mortgage as a "hard-nosed" or "realistic" approach to resolving an over-leveraged real estate investment. But it does serious damage to your credit; and, if the bank can't recover the full amount of its

loan to you when it sells the property, it can still sue you for the balance. Then, you would have both a foreclosure and a legal judgment on your credit. It's better to screw up your courage and negotiate a deal with the bank **before going into foreclosure**.

> These renegotiated deals—when made early enough, before foreclosure—may not show up in any form as a black mark on your credit. That's the main reason to make the telephone call to the secured lender before they make a collection call to you.

Likewise, if you fall behind in your car payments, the finance company that helped you buy the vehicle may repossess it.

As with real estate, car lenders don't like to repo vehicles. If you call the finance company when you're still current or just 30 days late on your payments, you can often negotiate a deal to reschedule payments or extend your existing loan.

> Auto finance companies are sometimes less organized about reporting late payments and repossessions than mortgage companies are about reporting foreclosures. If you act quickly to remedy a repo, there is some chance that you can fix the problem before it's reported to the credit bureaus. Make sure to ask the finance company about this—and get a written assurance that the repo hasn't been reported, as part of your reinstatement agreement.

If you don't get a repossessed car back, the lender most likely will sell the vehicle. And, as with a fore-closed property, you still may not be off the hook. If the lender sells the car for less than what you owe, you are still liable for the difference.

A "DOWNWARD SPIRAL"

More than any single problem, lenders and credit bureaus are **on the lookout for trends** that suggest borrowers are heading for trouble. They believe that, if they see broader signs of a "downward spiral," they can make better decisions about granting credit…or how to respond when a borrower asks for help. Credit bureaus are constantly modifying their reports in an effort to **spot trouble sooner**.

What constitutes a downward spiral? The March 2000 Massachusetts federal court decision *AT&T Universal Card Services v. Edmund Dietzal* offers one answer. In March 1998, Dietzel filed for personal bankruptcy to discharge his many debts. AT&T promptly sued, arguing that $4,144 Dietzel had charged on a credit card it issued to him shouldn't be wiped out because he'd committed fraud.

> The case turned on one question: Was Dietzel a credit card scammer who had no intention of repaying AT&T? Or was he simply a guy with money problems whose downward spiral AT&T would have noticed if it had been paying closer attention?

In his bankruptcy filing, Dietzel listed 100 percent ownership interest in a house in Dedham, Massachusetts, valued at $190,000. He also listed personal property that included: $250 in cash spread around several bank accounts; "furnishings" with a value of $2,000; and two automobiles, a 1997 Dodge Caravan and a 1997 Nissan Altima with values of $16,500 and $18,000, respectively. He claimed exemption for the house and personal property—which means he wanted to keep those things.

Among his listed debts were: two mortgages on the Dedham house totaling about $165,000; secured car loans equal to the full claimed value of his two vehicles; and nonsecured consumer loans—including the balance on the AT&T card—totaling $53,589. These nonsecured loans were almost all credit card debts, with the exception of about $6,000 in student loans and some medical bills.

Dietzel listed monthly income (from a part-time job and a small pension) of $1,400. His wife earned about $1,700 a month; together, they had three dependent children, ages 10, 14 and 16. In all, the Dietzel household's expenses exceeded its income by about $2,000 a month.

> At trial, Dietzel admitted he'd kept only a small debt balance on his AT&T card for most of the time that he'd had it. Through early 1997, he maintained a balance of less than $20. Then, in the late summer, he started using the AT&T card for small purchases and a number of cash advances.

Dietzel had been using credit cards heavily **to finance his middle-class life-style** since he'd lost his government job in late 1995. In February 1997, he consolidated this credit card debt—about $43,000, at that point—into the second mortgage on the Dedham house.

But **the borrowing continued**. In May 1997, Dietzel took a cash advance of $5,000 on a Compuserv Visa card; in June, he charged $2,000 for three round trip airline tickets to England and took cash advances totaling $800; in July, he took a $5,000 cash advance from Household Finance Company. That month, he took two of his children to England to visit a personal friend who was ill.

About that time, Dietzel's personal life was getting less stable. His wife moved out of the Dedham house for several months; the separation resulted in household expenses of at least $6,000.

From late 1996 through early 1998, Dietzel used cash advances from some credit cards to make payments on others. He explained:

I think I was able to make all the payments because if payments came due and I didn't have enough money, I would just use a credit card to pay the other credit cards.

In this manner, he ran up **over $40,000 in new credit card debt** in the 13 months after he took out the second mortgage.

Through this period, Dietzel held several jobs, including a promising position with a courier company called Minute Man Deliveries. But none of the jobs lasted; the delivery job ended after he got into a fight with a customer. Instead, in early 1997, he got a part-time job delivering *The Boston Herald*.

Should AT&T have seen Dietzel's troubles coming? Ronald Lewis, AT&T's bankruptcy specialist, testified that Dietzel's credit history didn't raise any red flags. He'd opened the account with AT&T in 1992; the account was subject to periodic review, which resulted in scores that were always "at a very good level." But Lewis explained how **credit card kiting** would effect the "scoring" or mathematical assessment of risk associated with the account:

> *It would maintain it at a good level. Kiting is basically the movement of money from one or more credit cards to other credit cards, and unfortunately, what happens until the bottom falls out, it creates a false illusion on the Credit Bureau that the individual has financial stability because everything is being paid as agreed. It completely masks any way to determine that there's a problem....*

Lewis noted that Dietzel contacted AT&T in August 1997 to explain that his August payment would be late because he broke his leg on vacation (an event Dietzel later admitted never happened).

After that contact—and an indirect contact for authorization for the October 1997 cash advance in the amount of $2,000—there was **no direct contact** between Dietzel and AT&T.

Dietzel made a last, partial payment on the account in November 1997. In early January 1998, AT&T began contacting him, seeking payment. He declared bankruptcy a few weeks later.

The trial court pointed out that, in order to **prove fraud** on Dietzel's part, AT&T had to establish the following elements:

1) that Dietzel made a representation;

2) that Dietzel knew the representation was false at the time he made it;

3) that Dietzel made the representation with actual intent to deceive AT&T;

4) that AT&T justifiably relied on the representations; and

5) that AT&T sustained a loss caused by the false representation.

Of course, it's not fraud simply to make a minimum payment with a cash advance from another credit card. This action must also be coupled with a **lack of intent to repay** the debt. Courts can infer this lack of intent to repay from a list of factors, including:

- the length of time between the charges made and the filing of bankruptcy;

- whether an attorney has been consulted concerning the filing of bankruptcy before the charges were made;

- the number of charges made;

- the amount of the charges;

- financial sophistication of the debtor;

- whether or not the debtor was employed; and

- whether the purchases were made for luxuries or necessities.

According to the court, "the correct focus...is whether **in good faith he intended** to keep his promise." AT&T argued that Dietzel didn't. And the court admitted:

> *{His} Schedules and Statement of Financial Affairs are replete with errors and omissions. ...Additionally, he lied to AT&T about breaking his leg to obtain an extension of time within which to make the August payment on his credit card.*

But this wasn't enough. The court said **Dietzel's untruths weren't substantive** and material to AT&T's complaint. AT&T had to establish that his representations were false when made and were made with the intention of deceiving it. On these matters, the court concluded:

> *At the time {Dietzel} obtained the cash advances, his financial condition was not good, but it was much better than it had been.... Although the total amount outstanding on {his} AT&T card exceeded {his} credit limit at the time he filed his bankruptcy petition this was in part due to finance charges as opposed to substantial charges over his credit limit.*

The court concluded that AT&T had failed prove that Dietzel had intended to defraud it at the time he obtained cash advances. In other words, it should have been paying closer attention. The monies

Dietzel owed on the AT&T credit card were discharged as part of his bankruptcy.

BEWARE OF CASH ADVANCES

Credit card companies often seem to encourage some level of kiting, since they advertise **balance transfers, cash advances** and devices like so-called "**convenience checks**" that make moving debt from one card to another easy.

> This shuffling of debt can be smart money management, if you're taking advantage of low promotional interest rates, etc. And, as we've noted, even credit counsellors suggest moving credit card debt around to avoid maxing out any one card.

But make sure that you have enough income to cover the debts when you make these moves. Otherwise, it can look like a fraudulent scheme. Another Massachusetts bankruptcy court decision—2004's *MBNA America Bank v. Joan Ashland*—offers an example of this.

Joan Ashland and her husband, John, owned their home in West Yarmouth, Massachusetts, where they lived with their three young children. There were domestic difficulties and John left the home about November 2001. He failed to make regular child-support payments; and Joan, who'd worked as a "personal care assistant", could no longer take overnight assignments since her husband wasn't

home with the children. This sharply reduced her income.

John left a number of items behind when he left. One was a balance on a "Citi Drivers Edge Gold Card." Although the card was in his name, both spouses had used it. By agreement between them, Joan had made the payments on the card and she'd never been late.

However, in February 2002, the issuer notified Joan that it intended to **increase the rate** on that card from 8.9 percent to 25 percent, based upon other aspects of her credit history. As a result, the payment which she was accustomed to make would result in a monthly principal reduction of only $2.

> Meanwhile, her money problems were mounting. She made an appointment with a bankruptcy lawyer and took stock of her finances.

Some months earlier, Joan had obtained a credit card from MBNA. That card was in her name only.

Each monthly statement from MBNA was accompanied by three checks, called "convenience checks." These checks could be used by the card holder for debt consolidation or consumer purchases. Their amounts were applied against the card's credit limit and carried a low promotional interest rate.

Dismayed by the increased rate on the Citi card, Joan took advantage of the MBNA convenience

checks. In late February, she used a check for more than $7,000 to pay off the Citi card balance.

A few weeks later, she deposited a second MBNA check for about $3,000 into her bank account. She used the funds for mortgage payments, a dentist bill and a retainer to…**the bankruptcy lawyer.**

Joan and her bankruptcy lawyer discussed various options. In mid-March, just a few days after using the second MBNA check, she gave her lawyer authority to file bankruptcy on her behalf.

Joan testified that, when she used the convenience checks, she intended to repay MBNA. But the meetings with the bankruptcy lawyer undermined that claim. The judge found Joan's testimony "less than credible" and ruled:

> *{Joan Ashland} was planning bankruptcy at the time that she used the convenience checks. …The representation was made with intent to deceive.*

So, the debt she'd run up on the MBNA card would stay in place, even after her bankruptcy.

BANKRUPTCY

From the last two case studies, you can see that bankruptcy cases **define a lot of the rules** about how credit card debt is handled by courts. But many people have a too-casual attitude toward bankruptcy.

Declaring personal bankruptcy should be considered the path of last resort (although some lawyers will tell you otherwise to get your business). In most situations, bankruptcy will damage your credit rating so severely that you won't be able to get credit of any sort for several years. There are some situations in which **bankruptcy can improve an extremely poor credit rating**—but these are rare.

The most common causes of personal bankruptcy are:

- unemployment;
- divorce and other marital problems;
- large unexpected expenses, such as medical bills; and
- seriously overextended credit.

Bankruptcy does have a profound affect on your credit score. It stays on your credit report for **10 years**—longer than any other black mark.

Also, a bankruptcy can be reported to insurers and potential employers for the rest of your life, which could make it difficult for you to get life insurance or get a new job.

However, your current employer may not discriminate against you because you filed bankruptcy. In fact, it is highly unlikely that your employer will find out, unless you reveal the information yourself—or the company is one of your creditors.

In spite of the obvious drawbacks to declaring bankruptcy, it is important to **at least consider** all options, if you are overwhelmed with debt.

Bankruptcy is a legal proceeding, in which a federal bankruptcy court discharges some or all of your debts. In other words, the court says you no longer have to pay the money you owe. The goal is to grant a fresh start to an honest consumer who is in debt way beyond his or her ability to pay.

Of course, you will have to pay something. At the minimum, there's a **filing fee** at the courthouse, along with an **administrative fee**—the total fee is usually about $200. You also may need to hire an attorney, and **legal fees** can vary dramatically.

> **When it comes to individuals, there are two main kinds of bankruptcy: Chapter 7 and Chapter 13.**

Specific bankruptcy rules vary from state to state, but the following is a general overview of your options. Both Chapter 7 and Chapter 13 allow you to:

- get rid of unsecured debts;
- stop foreclosures;
- stop repossessions;
- stop garnishments of your wages;
- avoid having your utilities shut off; and
- avoid dealing with debt collectors.

Once you have filed for bankruptcy protection, your creditors are required by law to **stop trying to collect**. They will be notified by the bankruptcy court, typically within a couple weeks of your filing, but you also can notify them sooner to stop the phone calls and other collection efforts.

Chapter 7 is the most common form of bankruptcy in the United States. In this proceeding, almost all of your assets will be liquidated to pay off your debts. In other words, you **turn over all of your property** (except items that are considered *exempt*) to a court-appointed official or trustee. The trustee then sells your personal property, and distributes the money to your creditors.

The court probably will liquidate:

- valuable collections, such as stamps or coins;
- antiques;
- stock, bonds and other investments;
- a second car or truck; and
- a vacation home.

But some of your possessions may be exempt from liquidation under Chapter 7 bankruptcy. Exemptions vary by state, and they also are determined based on an analysis of your situation. In general, **exempt property includes**:

- a primary residence;
- a car;
- work-related tools;

- pensions and retirement plans;
- life insurance;
- personal effects and clothing (though you probably won't be able to keep a mink coat); and
- basic household furnishings.

If you have many secured debts, such as several houses, a boat or several cars, your creditors likely will take back the property. But you'll usually be able to keep **your primary residence** and **one car**.

You can declare Chapter 7 bankruptcy more than once in your lifetime—but no more often than once every six years.

> **For this reason, some credit card companies offer cards to people who've just declared bankruptcy. The companies consider those people better credit risks because they can't declare bankruptcy again any time soon.**

Once you file all the paperwork, you will have to appear in court for a hearing, called the **First Meeting of Creditors**. The judge will question you regarding the information, your debts and assets, and so on. Your creditors also may appear at the hearing (though few non-secured creditors usually do).

Ordinarily, if everything meets with the court's approval, the court will issue your discharge within 60 to 75 days after the hearing.

Credit card issuers' reactions to a Chapter 7 filing can vary widely. For instance, you may be able to keep one or more credit cards when you declare Chapter 7 bankruptcy. It will depend on the balance on the cards in question, the desires of the credit card issuers and your ability to pay your credit card bills in the future.

On the other hand, as we've seen in this chapter, one or more of your credit card issuers may try to block the discharge of your debt to that company.

> If a credit card company files a non-dischargeability action, you may want to negotiate directly with the company to reach a settlement. In many cases, this is what the credit card company wants you to do.

Another option is to convert your filing from Chapter 7 to Chapter 13 bankruptcy, since even debts tainted by fraud can be discharged there.

Chapter 13 bankruptcy is quite different from Chapter 7. Rather than a liquidation program, Chapter 13 involves **a repayment plan**.

If you can prove that you have regular income, and if you have relatively little nonsecured debt, a Chapter 13 filing may allow you to keep property that you otherwise might lose if you didn't declare bankruptcy, or if you declared Chapter 7.

With a Chapter 13 filing, the court will approve a repayment plan negotiated between you and your

creditors. So, you will have to pay back at least some of the money you owe—usually within three to five years—rather than give up your property.

Whether you declare Chapter 7 or Chapter 13 bankruptcy, you still will be responsible for:

- child support payments;
- alimony;
- taxes (in most cases);
- non-dischargeable debts from a prior bankruptcy; and
- student loans.

Divorce plays a big part in personal bankruptcy filings. If you are separated or divorced from someone who declares bankruptcy, your credit can be affected—especially if there's still joint debt or joint property. Also, child support and custody arrangements can be affected. We discuss family matters in more detail in Chapter 10.

DEBT REAFFIRMATION

After a debt is discharged in a bankruptcy proceeding, you can still choose to repay it. This is known as **debt reaffirmation**—and it can have some good effect in your credit rating, much like getting a reinstatement on a foreclosure or paying a charge-off (though a reaffirmation doesn't have quite as positive an effect as those other cures).

Reaffirmation agreements must be filed with the bankruptcy court. To be approved, they:

- should be undertaken voluntarily;

- must be in your best interest; and

- must not unduly burden you or your family.

Some credit card issuers and retailers have begun approaching consumers after their debts have been discharged by a bankruptcy, pressuring those consumers to reaffirm their debts—in exchange for issuing the bankrupt people **new credit cards**.

If you have declared bankruptcy, you do not have to reaffirm any of the debts that were discharged. And, while reaffirming may improve your standing with a particular creditor, it has only a minor effect on your credit. A better strategy for improving your credit is to pay all of your non-discharged and new debts in a timely manner.

While some credit card issuers will try to get consumers—often unwittingly—to reaffirm a debt that was defaulted on when they apply for new credit cards, these companies cannot force you to reaffirm a debt that was discharged via a bankruptcy.

CONCLUSION

In this chapter, we've considered the main credit issues—black marks and red flags—that lenders look for when they're considering a loan or reviewing an account. There's a big difference between one 30-day late payment and bankruptcy; but both items affect your credit score badly.

Credit bureaus and the lenders they serve are secretive about the specific effects that one or two late payments...or a charge-off, etc....will have on a specific person's credit score. But we do know that credit bureaus are constantly trying to **improve their abilities to spot trends**. They want to see "downward spirals" when they're just beginning.

As a smart consumer, you should be on the same lookout in your own finances. The best advice that we can offer from all of this black mark information is: If you suspect you've got money troubles brewing, contact your lenders while your payments are still timely. Let them know you're going to need some help.

And keep as much as you can writing.

IF YOU'RE HAVING
MONEY PROBLEMS

Some people use credit so poorly that they get into major money problems. They aren't necessarily dumb; they just don't plan well. They count on steady income and then lose their jobs...or they suffer unexpected health problems or family crises that wreck assumptions about their abilities to pay.

If you're working overtime or two jobs and still can't cover your living expenses and minimum interest payments, **you've got money problems**. But don't despair. Thousands of people are in the same situation.

> The question is: What can you do when money problems get serious? Some will say you have to declare bankruptcy. But that's not necessarily true. Bankruptcy really works best for people with assets (a business or real estate, etc.) to protect.

If you don't own a home or business and your debt is largely **unsecured consumer credit**, you may

do better to consider some options to bankruptcy... and the years of damaged credit it involves.

MAKE A SIMPLE BUDGET

The first step is to **take stock of your current situation**. Gather your bills and your pay stubs and get ready to make some lists.

Start with your total **net income**. How much money do you (and any other members of your household) bring home each month?

Then make a list of your **fixed expenses**—i.e., the expenses that are the same every month—including the amount of each payment. This can include:

- your mortgage or rent,
- car payments or other transit costs and
- student loan payments.

> **If you have expenses that you pay quarterly, semi-annually or annually, such as insurance premiums, tuition or property taxes, be sure to budget money for these expenses each month, too.**

Next, make a list of **expenses that vary** from month to month. This list will include such items as:

- food;
- gasoline and other transit expenses;

- entertainment and recreation;
- clothing; and
- credit card payments.

Go back through your bills and your checkbook for the **past three months**, and make an average of what you spent on each of these variable expenses. Then record an average amount next to each item.

> If you're experiencing a financial crisis, odds are that your expenses exceed your income. Are there any expenses that can be reduced, such as entertainment, clothing and recreation?

By setting up a tight budget, you may be able to meet your expenses with your current income.

Naturally, the goal is to take care of the basics— like staying in a safe home, having enough food to eat, being able to get to your job, keeping up your insurance payments and so on. Then see how much money you have left each month to **pay your debt**.

PAYING DOWN YOUR DEBTS

If you have enough income to start paying down your debts, the key is to **attack one debt at a time**. You should **make the minimum monthly payment on all of your debts** and then pay as much extra as you can on one debt every month until that one is paid off.

It's rarely wise to pay off long-term secured debts, like an auto loan or a home mortgage, before you pay off unsecured debt, like credit card accounts and medical bills. **Focus first on unsecured debt.**

To identify where you stand and which unsecured debts to pay off in which order, grab your bills again and make another list. You'll want to write down:

- the type of debt (e.g., Providian Visa card or orthodontist's bills);

- the total amount you owe;

- the minimum monthly payment; and

- the interest rate.

There are a couple ways to go when choosing which account to pay off first. Some experts recommend paying off the debt with the **highest interest first**, and that makes good financial sense. But, if that account has a high balance and you have another account with a much smaller balance, it can be good for your morale to pay off the smaller debt first.

> **Regardless of which account you choose to pay off first, stick with it. Plan to pay the same amount each month on that debt until it's paid off. For instance, if the minimum monthly payment is $256 and you can make a payment of $300 each month, do that until the outstanding balance is zero.**

Then, take that $300 you were paying each month and add it to the minimum monthly payment on

the next debt you're going to pay off. So if the minimum monthly payment on the next account is $175, you'll now pay $475 each month.

If you pay off one account at a time, and continue making the same payment—in total—every month, you'll get rid of all of your debt. Assuming you **aren't making new charges** at the same time. So, put away the credit cards while you're repaying.

CONTACT YOUR CREDITORS

Once you've made a budget and started paying down your debts, your next step is to contact your creditors, preferably in writing.

Explain your situation. Your creditors' response probably will not sound terribly sympathetic, because they hear stories like yours all the time. But don't let that trouble you.

> **Your goal is not to gain their sympathy, but to negotiate a modified payment plan that will reduce your monthly payments. Obviously, you'll want to reduce them to an amount you can realistically pay each month, based on your budget.**

You also want each creditor to continue reporting your accounts as "current," so as not to affect your credit score. Many will agree to do this; but you usually **have to ask**...and have to keep a schedule of payments that you set.

Bear in mind that you will have to **pay more in interest** if you extend your repayment schedule, but this technique will allow you to stay current and maintain your credit rating.

Another option is to have creditors **change the due date** on your payments in order to balance out your monthly expenses—so you don't have most of your bills due on the first of the month, for example.

The sooner you can negotiate with your creditors about modifying your payment schedule, the better for you and your credit ratings.

Make the telephone calls as soon as you see hard times coming. Don't wait until you've missed a payment, or until your accounts have been sent to collections.

LATE PAYMENTS

Late payments will put a real crimp in your credit rating. However, different creditors report late payments differently. Some only report late payments that are 60 days behind to the credit bureaus; others report payments that are just 30 days past due.

If you can determine which of your creditors report payments that are 60 days past due, you may be able to **juggle which accounts you pay first** and gain a little extra time to get your financial house in order. This is a short-term technique, but it can help a bit.

RE-AGING YOUR ACCOUNTS

Re-aging your accounts is a technique you can use to clean up your credit history, particularly if you had a brief problem and you're back in control.

> **Basically, when an account is re-aged, it is no longer considered past due. The creditor simply relabels the account "current."**

Let's say you are three months late on one of your credit cards. If you can convince the credit card provider to re-age your account, it's as if those three months never happened. You still owe the same amount of money, but the late fees stop and you are no longer considered delinquent. Your missed payments are simply ignored.

Re-aging an account can be really good for your credit score. A big "late" blemish comes off your account and it's considered current.

Getting a creditor to re-age your account is not easy—and it's not something you can do often. The best approach is to offer some form of **payment immediately**, plus offer a schedule of more-than-minimum payments, in exchange for the re-aging.

There are government guidelines concerning re-aging, which have been set out by the **Federal Financial Institutions Examination Council** (FFIEC). The FFIEC is an interagency government body that prescribes uniform principles, standards

and report forms for the federal examination of financial institutions and makes recommendations to promote uniformity in the supervision of financial institutions.

According to the FFIEC, for an opened-end loan—like a credit card account—to be eligible for re-aging, it must meet the following conditions:

- the borrower should show a **willingness and ability** to repay the loan;

- the account should exist for **at least nine months**;

- the borrower should make at **least three consecutive monthly payments** or an equivalent lump sum payment;

- a loan should not be re-aged more than once within any 12-month period; and

- new credit should not be extended to the borrower until the **balance falls below the pre-delinquency credit limit**.

But there's no point in calling and e-mailing and begging a creditor to re-age your account if there is any chance that you will wind up **delinquent again** in the near future. Save your energy and time for other credit-saving efforts.

If you are committed to making at least the minimum monthly payments, on time, moving forward, then you'll need to contact your creditor or creditors in writing. Tell the company:

- why you were late on the payments in question; and

- why you know you'll be able to pay on
 time in the future.

Get an agreement to re-age your account **in writing**. Many consumers have been told over the phone that a creditor will re-age their account, only to discover that the re-aging never takes place.

If the card company won't put the agreement in writing, you can take matters into your own hands.

Ask the customer service agent to give you the name and mailing address of his or her supervisor. Then, write a letter describing your conversation in detail, state that **you believe this is an agreement to re-age your account** and send it via certified mail, with a return receipt, to the supervisor.

WHAT WILL CREDITORS DO?

If you've fallen behind in your payments, some companies that make their money off of "helping" will make it sound as if creditors are going to be **taking you to court**, securing a judgment against you and garnishing your wages and seizing your property very soon. If you don't sign up for their services, these companies say, you can expect sheriffs to come knocking on your door any moment. (Collection agencies also play this tune.)

It is likely that your car will be repossessed if you miss payments on it. And it's likely that the bank that holds your mortgage will foreclose if you miss several payments on your home. Those are secured debts; **the property serves as collateral**.

But when it comes to unsecured debt, especially credit cards, it is *unlikely* that a creditor will take you to court to collect a few thousand dollars.

> We're not saying it never happens. But the odds of it happening to you are relatively slim, simply because there are so many consumers who have debt repayment problems. Taking every one of them to court would be exorbitantly expensive for lenders.

Therefore, what creditors normally will do is report your bad behavior to credit bureaus, which affects your credit rating. And, eventually, they turn your account over to a collection agency.

COLLECTION AGENCIES

Collection agencies work on what is, essentially, a commission basis. They get a cut—sometimes as much as 50 percent—of any money they collect. The rest of the money then goes to the original creditor.

> In a few cases, collection agencies will actually buy debts from credit companies and collect these debts as their own. However, this practice has come under closer government scrutiny...so it's not as appealing to collectors as it once was.

Needless to say, collection agencies are very motivated to extract whatever money they can from you. That's how they get paid.

That's one reason people at collection agencies are not known for their charming telephone demeanor. However, they also cannot get on the phone and simply rail at you, day and night.

DEBT COLLECTION LAWS

There is a federal law that dictates how debt collectors may—and may not—deal with consumers. It's called the **Fair Debt Collection Practices Act** (FDCPA), and it applies to personal debts, including money owed for an auto or home loan, for medical care and for credit card accounts.

According to the Federal Trade Commission (FTC), under the FDCPA, a debt collector:

- may not call you before 8 a.m. or after 9 p.m.;

- may not call you at work, if the debt collector knows that your employer does not approve of such phone calls;

- may not harass, oppress or abuse you;

- may not lie, and may not falsely imply that you have committed a crime;

- may not use unfair practices to try to collect a debt;

- must identify himself or herself to you on the phone; and

- must honor a written request from you to stop further contact.

The March 1999 Arizona federal court decision *Michelle Caron v. Charles E. Maxwell, P.C., a Professional Corporation, et al.* applied some of the critical elements of the FDCPA.

Caron owned a home in a development that included big homeowners' association dues. She fell behind in her dues—and the association turned her account over to Charles E. Maxwell, "an attorney engaged in the business of collecting consumer debts."

Maxwell used a variety of **threats and aggressive tactics** to collect the overdue dues. Caron sued him and her homeowners association under the FDCPA.

Specifically, she claimed that Maxwell violated the law by "falsely representing that he would be entitled to collect accruing attorneys fees and costs pursuant to the terms of a judgment obtained by [the association and] by threatening to take action that cannot legally be taken."

She said that Maxwell sent her a letter stating that, if she did not respond within 10 days, the homeowners' association would exhaust all of its legal remedies against her, including a **Sheriff's sale of her property**. She complained that Maxwell's conduct was "extreme and outrageous." And she argued that the homeowners association should be held liable for his bad actions.

The trial court pointed out that the FDCPA imposes liability only on debt collectors—not on creditors. So, the association was off the hook.

But Maxwell wasn't. He asked the court to dismiss Caron's charges against him. It would not. The court noted that the purpose of the FDCPA is to

> *eliminate abusive debt collection practices by debt collectors, to insure that those debt collectors who refrain from using abusive debt collection practices are not competitively disadvantaged, and to promote consistent State action to protect consumers against debt collection abuses.*

And this description seemed to apply to Maxwell's actions.

Another important part of the FDCPA states that collection agencies have to be **specific about what a debtor owes** when they try to collect. The March 2004 United States Court of Appeals (Seventh Circuit) decision *Caldean M. Chuway v. National Action Financial Services* shows why this is important.

National Action Financial, a debt collection agency, mailed Chuway a letter which identified its client (a credit card company) and stated that the "balance" Chuway owed the company was $367.42. The letter added that the company had "assigned your delinquent account to our agency for collection. Please remit the balance listed above in the return envelope provided. To obtain your most current balance information, please call [a toll free number]."

Chuway didn't know whether the collection agency wanted just $367.42 or some unknown greater amount that she could find out only by calling the toll free number. Instead, she sued, arguing that—under the FDCPA—the letter failed to state clearly how much was owed.

The trial judge disagreed, ruling that the letter stated "the amount of the debt" and therefore did not violate the statute. Chuway appealed. And the appeals court thought better of her arguments.

At trial, National Action Financial's lawyers had admitted that the entire debt that the company was hired to collect was the $367.42 listed as the "balance." But the letter suggested that **the amount due might be different**. The appeals court noted:

> ...if the letter had stopped after the "Please remit" sentence, {National Action Financial} would be in the clear. But the letter didn't stop there. It went on to instruct the recipient on how to obtain "your most current balance information."

The appeals court ruled that this was an unfair tactic for the collection agency to use:

> Suppose she had called and discovered that her current balance was $567.42. She wouldn't know whether to mail $367.42 ...or $567.42, without making a further inquiry. She might pay the larger amount thinking she would be sued otherwise, even though the extra $200 might not yet be due, let alone overdue.

WHAT COLLECTORS CAN'T SAY

The appeals court emphasized that, under the FDCPA, It is not enough that a collection demand letter state the amount of the debt that is due. It must state it **clearly enough that the recipient is likely to understand** it:

Otherwise the collection agency could write the letter in Hittite and have a secure defense. ...one doesn't have to be ingenious to misread {National Action Financial's} letter; one has to be exceptionally ingenious to excavate its meaning.

If a debt collector is trying to collect only the amount due on the date the letter is sent, then it complies with the FDCPA by stating the balance due, stating that the creditor "has assigned your delinquent account to our agency for collection," and asking the recipient to remit the balance listed—**and stopping there**.

If a debt collector is trying to collect the listed balance plus the interest running on it or other charges, it should use language outlined by federal courts:

As of the date of this letter, you owe $____ {the exact amount due}. Because of interest, late charges, and other charges that may vary from day to day, the amount due on the day you pay may be greater. Hence, if you pay the amount shown above, an adjustment may be necessary after we receive your check, in which event we will inform you before depositing the check for collection. For further information, write the undersigned or call 1-800- {phone number}.

THINGS *YOU* SHOULDN'T SAY

If you get calls from a collection agency, try to remain calm. And whatever you do, **don't give out any additional information** about yourself. Specifically, don't tell a collection agency:

- where you work; or
- the bank or banks where you have accounts.

This information only makes it easier for the collection agency to get a judgment against you in court.

> **If the collection agent asks where you work or asks about your bank point-blank, don't engage in a legal debate. Simply reply, "No comment."**

You shouldn't commit to paying a bill that you don't have the money on hand to pay. Some collection agencies will try to get you to commit to a payment plan or **make a postdated check payment** over the phone. This may seem attractive, since it buys you time to pay; but, if you have doubts about the money, don't agree. Bouncing a check to a collection agency creates a bigger claim.

STATUTE OF LIMITATIONS

Did you know that there's a **statute of limitations** on various kinds of debt? That means that creditors only have a certain amount of time in which they can legally sue you to collect on a debt.

The statute of limitations will **vary from state to state,** and also based on **the kind of debt** in question. For instance, it is different for credit card accounts than it is for mortgages.

The clock starts ticking on the statute of limitations from the last date of any activity on an account. So if you made your last payment on a credit card in January 2001, and you live in Arizona, the statute of limitations on that account expired in January 2004. And that makes your debt, legally, "uncollectible."

The delinquent account will **still show up on your credit report** for seven years. But creditors—and collection agencies—can no longer collect the money from you after the statute of limitations runs out.

That doesn't mean they won't try, though.

You need to know the statute of limitations for your state—and, if you've moved, for the state you lived in when you signed the agreement for the debt in question. Your state's Attorney General's office will usually have this information available by phone or on the Internet.

If a creditor or collection agency approaches you after the statute of limitations has expired on a debt, you can simply tell them the debt is no longer collectable. In other words, the company can no longer go to court and get a judgment against you.

It's wise to have proof. One way to prove the date of the last activity on your account is to get a copy of your credit report. It will list the **dates as reported by your creditor**, which makes solid proof if you ever have to go to court over the debt.

NEGOTIATING WITH COLLECTORS

If the statute of limitations has not expired—and it is not about to expire—on a debt, and it has been sent to collections, you may be able to negotiate with the collection agency.

> If the collection agency has stopped calling you, you're actually in a better negotiating position, because the silent telephone means the debt collector is not optimistic about getting paid.

If you can, it's a good idea to negotiate with the collection agency **face-to-face, in person**. Most are not set up to do this—and are likely to be more flexible when sitting across from you than talking on the phone.

If you have to negotiate by phone, be sure to **take notes**, including the date and time of the call and the full name and title of the person with whom you are speaking.

You can also conduct the entire negotiation in writing, if you prefer. If you do, be sure to keep copies of all correspondence, and send your letters certified with a return receipt.

Naturally, you will want to deal with a person who is empowered to make a settlement decision. There's no point in pleading your case to someone, only to have to do it again for his or her supervisor.

Figure out beforehand how much you can afford to pay on this debt immediately.

The collections agent will usually turn down your first offer. So don't start with the maximum amount you can afford to pay. Instead, start with a low-ball offer, perhaps 40 cents or 50 cents on the dollar. So if you owe $5,000, you might offer a settlement of $2,000.

When the agent **turns down your first offer**, ask what it will take to reach a settlement. Expect to go back and forth a few times. Collection agencies are trained to ask questions and press *you* for answers; if you ask them questions about what it will take to settle an account, you take back some control of the exchange.

Whatever you do, don't agree to pay more than you can afford.

WHY WILL A CREDITOR SETTLE?

If someone owed you a big chunk of money, your first inclination would be to get the entire loan repaid. But would you ever settle for less than 100 percent?

You might, if you thought it was the only way you were going to get any of your money back. You also might if you thought the person who owed

you money didn't have anything of any value that you—or he or she—could sell to come up with the money owed.

Your creditors think the same way. If they believe that there's no point in taking you to court and getting a judgment against you because you don't have any assets anyway, they're **more likely to settle**.

> And if they believe that you only have a small chunk of money, and you're either going to give it to them or give it to one of your other creditors who is more inclined to negotiate a settlement, they too will become more inclined to settle.

Typically, the best deal you can get with a creditor or a collection agency is a 50 percent settlement— where you pay 50 cents on the dollar.

But if your account has gone to a second or even a third collection agency, there is a much lower expectation that you will actually make good on your debt. In that case, you may be able to negotiate a deal as low as 33 cents on the dollar.

Also, when negotiating your settlement, ask to have **penalties and extra interest dropped**. Most creditors will do this, as long as there's a chance that they will recoup at least part of the original debt.

The longer a debt has been around, the more likely creditors are to settle. And the less eager you appear, the better your negotiating position. That's

why you never want to accept the first settlement offer. And you probably will not want to accept the second offer, either.

If the statute of limitations is going to expire soon, don't be afraid to mention that during negotiations. It can tip the scales in your favor.

> **Don't volunteer information. If the collector knows you need to clear up a debt in order to qualify for a loan for your dream home, you have virtually no chance of coming to a good settlement.**

Some experts suggest that you threaten bankruptcy. If this is a debt that would be discharged under bankruptcy protection, then the creditor may be willing to settle—since getting something now is better than getting nothing later.

However, you must **be careful when you threaten bankruptcy**. If you rack up more debt on an account after you threaten bankruptcy, you may wind up unable to discharge this particular debt.

NEGOTIATING YOUR SCORE

In addition to negotiating a dollar amount for a settlement, you should use the negotiation to **manage the effects on your credit report** as much as possible.

Ideally, you would like:

- the collection agency to remove its listing from your credit report entirely; and

- the original creditor to show your bill as "Paid as Agreed," or "Account Closed/Paid as Agreed."

At the very least, you want any derogatory remarks taken off your credit report, and you want the account to be listed as **"paid in full," even if you have negotiated a reduced settlement.** Ask for these things when you offer to settle. And get the collector's response in writing.

Worst case scenario: You might agree to have the original creditor show the account as "settled," if any negative comments, such as "charge-off" or "collection" are removed.

"Settled" is not the best way to have an account listed on your credit report. Having a settled account can trigger a denial of credit later on.

You may be able to have the account removed from your credit report once it has been paid, if you use the consumer reporting agency's dispute process.

ONCE YOU HAVE AN AGREEMENT

Before you leave the collection agency's office (or get off the phone, if you couldn't negotiate in person), get everything you've agreed upon in writing. If you are negotiating by phone, have a fax

number ready before you call, so you can get the
agreement faxed over immediately.

As soon as you've reached an agreement and gotten
it in writing, you will need to pay the agreed-upon
amount. Usually, you can either return with the
funds or overnight the money.

**Do not give the company a personal check. Pay off
the settlement with a cashier's check or a money
order, and do not purchase it at your own bank.**

You do not want the collector—and potentially any
other creditors to whom you owe money—to know
your bank account number.

Also, be sure to keep a copy of the cashier's check or
money order. You want to have **proof that you have
paid** this debt.

If you have negotiated a settlement for less than the
full amount owed, you also will want to make a
special notation on your check. It should say some-
thing like: *Cashing this check constitutes payment in full
on account number XXX-XXX-XXX.*

**In most states, creditors cannot come after you for
the balance of the debt if they have cashed a check
that is so labeled.**

CREDIT COUNSELORS

If you're having troubles and you don't feel comfortable negotiating with creditors or collection agencies—or simply do not have the time to do it yourself—there are **professionals who can help**.

Credit counseling services are designed to help consumers get their finances under control. They can:

- help you create a budget;
- help you prepare to apply for a home loan;
- provide a variety of educational services; and
- put together a debt management or debt consolidation plan.

Some credit counseling services are non-profits and some are not. Some are staffed by certified credit counselors and some are not. Some offer their services for free and some do not.

The Federal Trade Commission (FTC) warns:

Beware—just because an organization says it is "nonprofit" doesn't guarantee that its services are free or affordable, or that its services are legitimate. In fact, some credit counseling organizations charge high fees, some of which may be hidden, or urge consumers to make "voluntary" contributions that cause them to fall deeper into debt.

You may be able to find a reputable credit counselor close by. For instance, nonprofit credit counseling programs are offered by many:

- credit unions;
- universities;
- military bases; and
- local housing authorities.

If these avenues aren't available or aren't convenient, you might ask for a referral at your bank or contact your local consumer protection agency.

AVOIDING SCAMMERS

While there are many reputable credit counseling services, there are also a lot of people who prey on consumers with financial difficulties.

Here are a few tips that will help you tell the good guys from the bad guys.

Good Signs:

- The credit counseling agency sends you free information, no questions asked.
- The company offers free educational materials.
- The company is willing to help you, even if you can't afford to pay.
- Counselors work on salary.
- The counselors are certified, preferably by an outside organization.
- The counselors will negotiate with creditors to get you the best possible terms and credit reporting options.

Bad Signs:

- The company wants you to provide details about your situation before sending you information.

- The company charges for everything.

- Counselors get paid more if you sign up for a certain service, or if you pay a fee or make a contribution to the organization.

- The counselors have not gone through a certification process.

- The counselors say they will make sure negative (but accurate) items are removed from your credit report.

Once you locate potential counseling agencies, you should contact your state Attorney General, local consumer protection agency and the Better Business Bureau to find out if there have been any complaints against the companies you're considering.

The FTC offers the following suggested questions to use when you interview potential counsellors:

- What services do you offer? (Look for an organization that offers a range of services, including budget counseling, and savings and debt management classes. Avoid organizations that push a debt management plan [DMP] as your only option.)

- Do you offer information? Are educational materials available for free?

- In addition to helping me solve my immediate problem, will you help me develop a plan for avoiding problems in the future?

- What are your fees? Are there setup and/or monthly fees? (Get a specific price quote in writing. Plans with monthly fees can be expensive over time.)

- What if I can't afford to pay your fees or make contributions? (If an organization won't help you because you can't afford to pay, look elsewhere.)

- Will I have a formal written agreement or contract with you? (Don't sign anything without reading it first.)

- Are you licensed to offer your services in my state?

- What are the qualifications of your counselors? Are they accredited or certified by an outside organization? If so, by whom? If not, how are they trained?

- What assurance do I have that information about me—including my address and financial information—will be kept confidential and secure?

- How are your employees compensated? Are they paid more if I sign up for certain services, if I pay a fee, or if I make a contribution to your organization?

You can work with a credit counselor in person, on-line or by phone—but **face-to-face meetings are usually most effective.**

You should **bring as much information as possible** to your first meeting, including current bills, copies of your credit reports and the files from any negotiations you've already started. The agency should tell you specifically what to bring.

During the meeting, the credit counselor should:

- review your financial history;
- talk about the problems you're dealing with right now; and
- communicate with you in a non-judgmental way.

The next step is for the counselor to set up a **plan to help you become debt-free**.

Don't expect this to happen overnight. **It usually takes three to five years** to become debt-free, even working with a credit counseling service.

In some cases, credit counselors may simply help you set up a budget and a pay plan to get your credit back in shape. Or they may recommend a **debt repayment (or management) plan**.

> A debt repayment plan is designed for people who cannot manage all the monthly payments for their current debt load. The credit counseling service negotiates with each (or at least most) of your creditors. You then make one payment each month to the credit counseling agency. And the agency distributes the money to your creditors.

To participate in some debt repayment plans, you will have to agree that you will not apply for or use any additional credit until the plan has ended.

The benefits of participating in a debt repayment plan can include **reduced or waived finance charges** and **fewer collection calls**. However, the degree to which a plan can help or hurt you—and your credit—varies dramatically.

How is it that some debt repayment plans help your credit rating, while others trash it? It all depends on the deal the credit counseling agency negotiates on your behalf.

As part of your debt repayment plan, the credit counseling agency should be able to:

- arrange a more favorable repayment schedule with your creditors;

- lower the interest rate on your credit cards;

- get each creditor to stop charging late fees; and

- get each creditor to re-age your account, so the account now shows up on your credit report as current.

In some cases, you will have to be on the plan for a certain period of time for benefits to show. According to the FTC:

> *Some creditors require a payment to the credit counselor before accepting you into a DMP. If a credit counselor tells you this is so, call your creditors to*

verify this information before you send money to the credit counseling agency.

Also, confirm with your creditors that they have accepted the proposed debt repayment plan before you sign the contract and start making payments to the credit counseling agency.

And confirm with the agency that your bills will all be paid before their due dates.

You also need to be very clear about **which creditors** are—and are *not*—included in the plan. It's possible that some of your creditors will refuse to participate, in which case you'll have to continue paying them directly.

You need to **review your monthly statements from each of your creditors,** too, to be sure they are receiving payments according to the terms of your repayment plan. You should verify that:

- payment was received on time;
- the interest rate has been lowered, as negotiated; and
- finance charges and late fees are as negotiated (preferably waived).

A well-negotiated debt repayment plan should help to improve your credit history moving forward. If you uphold your part of the plan, you will be proving to future potential creditors that you can pay on time, every time—a quality that lenders prize.

However, a debt repayment plan **will not erase any negative history** already on your credit report, such as a history of late or missed payments. This

information still will remain on your credit reports for up to seven years.

Some creditors also may report your accounts as being in financial counseling, or being handled through a debt repayment program. This is **less favorable for your credit rating**, so press your credit counselor to ask for a better credit reporting option, whenever possible.

> **Debt repayment plans usually cover only unsecured debt; they don't include home loans, auto loans and other types of secured debt. You'll need to continue making payments to these creditors directly.**

DEBT CONSOLIDATION

Some people refer to debt repayment plans as "debt consolidation." But the term more commonly is used to describe taking out a home loan to repay debts.

For instance, you may be able to lower your monthly payments dramatically—and lower the interest rate you are paying on your debts—by refinancing your home or taking out a second mortgage or home equity line of credit.

> **As appealing as this option sounds, be careful. First, pay attention to points or other fees associated with the home loan. They can be cost-prohibitive.**

If there is any chance that you will not be able to make the payments on the consolidation loan, remember: You've put your house on the line as collateral. You don't want to lose it.

Still, on the plus side, there can be some **tax advantages** associated with paying interest on a home loan, rather than paying interest on credit card debt.

PLAYING HARDBALL

If you don't feel comfortable negotiating with creditors yourself but you want to take a harder position with them, you can use a **debt negotiation firm**. These companies are not the same as credit counseling agencies, though there is negotiation involved in the creation of many debt repayment plans.

Debt negotiation companies often claim that they can save you a bundle by getting your creditors to accept less than you owe—often from 10 to 50 percent of your balance. But there are a lot of sharks in the debt negotiation market; so, many states keep **close tabs on these companies**, regulating the services they offer and how they advertise.

> Like a credit counseling agency, a debt negotiation company will tell you to stop paying your creditors directly and instead send payments to it, which will pay creditors for you. Unlike a counseling agency, a debt negotiating firm will usually take an antagonistic stance in dealing with credit card companies.

Some debt negotiation companies promote their services as an **alternative to bankruptcy** and a better move as far as your credit rating is concerned. Others claim that any **negative information added to your credit report can be removed** when you have completed the debt negotiation process. This is true in some cases—but it's not a certainty.

In fact, many debt negotiators will advise you to stop making payments on your nonsecured debt for a period of time before they approach the creditors. The idea is that it will make the credit card companies believe that you're going to go bankrupt—and they'll get nothing. It's a **hardball negotiating tactic** that can devastate your credit.

If you stop making your monthly payments, you'll be racking up late fees and, soon enough, finance charges computed at hefty penalty interest rates. If you go over your credit limit in the process, even more charges and penalties will be assessed.

Plus, your creditors will be reporting your accounts as delinquent, further affecting your credit score.

Meanwhile, the debt negotiation firm has been charging you lots of fees, too.

> **Even if the debt negotiation company performs as promised, you still may wind up in worse shape, financially, than you started out, with a badly battered credit report on top of it.**

Then, to make matters worse, you may owe the Internal Revenue Service money. **Forgiven debt can be considered taxable income.**

Just as you should do due diligence to check out the validity of a credit counseling agency, you also should contact your state Attorney General or the Better Business Bureau to check out any debt negotiation company with whom you might work.

CONCLUSION

Getting past money problems requires four steps:

1) seeing that you're in trouble;

2) cutting back on your spending;

3) negotiating your debts;

4) repaying debts, steadily.

You can get help with steps 2 through 4. But you have to see the problem yourself, first, before anything else can happen.

10

FAMILY ISSUES

A marriage is more than a blending of life-styles, furnishings and families. It's a blending of credit scores. Sometimes this combination is for the better; sometime it's for the worse.

Your spouse has considerable ability to mess up your credit score with his or her actions, **even if they happened years ago**. This is a connection that is unlike any other. Other family members—parents, children, siblings—aren't **automatically connected** to your credit. But your spouse is.

> It's rare for married people to have very different credit scores. Even though a husband and wife almost always have a slightly different score, they usually end up within 50 points of each other after several years of marriage.

But even your extended family can mess with your credit, if you aren't careful. In this chapter, we'll discuss how to be careful.

COMMUNITY PROPERTY

Some states in the United States have **community property laws**. In these states, each spouse is liable for the other's debts, period. The only major exception is the purchase of real estate; **both spouses' signatures are required** on real estate loans and transactions. On all other credit accounts, in a community property state, you can be held liable for debt you never even knew existed.

Community property states are: Arizona, California, Idaho, Louisiana, Nevada, New Mexico, Texas, Washington and Wisconsin.

If you don't live in a community property state, you're less at risk for your spouse's debts. It all comes down to what sort of accounts your spouse has: **joint or individual**.

When you apply for credit, whether a mortgage or a credit card, you must select whether it will be a joint or an individual account. If your spouse has opened an individual account, his or her credit alone was considered by the creditor, and your spouse alone is responsible for making good on the account.

If you open a joint account, both of your credit histories are considered, and both of you are liable.

AUTHORIZED USERS

Sometimes, one spouse will open an individual account and name the other spouse—or a child or parent or another party—as an **authorized user**.

This can be good way to help a child get started as a credit user. But it can also be a dangerous deal.

With a credit card, the authorized user will receive his own card with his name on it. He can use it to his heart's content (or at least up to the card's credit limit). The account also will appear on the user's credit report; however, only the person who opened the account will be liable for paying off the debt.

You should **be very careful whom you name** as a user on your accounts, since there's considerable potential for financial pain.

The May 2001 Connecticut Appeals Court decision *Citibank (South Dakota) v. Mark Gifesman* offers one wretched example of how bad things can get with authorized users on credit cards.

In April 1995, Gifesman requested from Citibank a secondary card in the name of Alexei Popov, a Russian national living in Russia.

> **Gifesman didn't actually know Popov. He requested the card as a favor to Vladislav Kharkover, a friend who was a Russian national living in the U.S. Kharkover agreed to pay for charges arising out of the use of the Popov card and, in addition to that, to pay Gifesman a $25 monthly fee.**

The Popov card was used extensively in Germany during July 1995, resulting in charges totalling over $36,000.

On July 20, 1995, Citibank notified Gifesman of the attempted use of the Popov card for cash advances, the only activity associated with the Popov card of which Gifesman was then aware. The following day, Citibank again contacted Gifesman to ask—again—whether he wanted to block further use of the Popov card. Gifesman asked Citibank not to cancel or block the card.

The day after that, Citibank listed the Popov card as possibly lost or stolen and shut it down.

> **Gifesman didn't pay the two bills—totalling nearly $50,000—related to the Popov card. He argued that he wasn't responsible for the charges because Popov didn't know who'd made them. Citibank didn't believe this story and sued Gifesman.**

Gifesman filed a countersuit, charging Citibank with breach of fiduciary duty and bad faith.

The court dismissed Gifesman's arguments. It ruled that he had "conferred apparent authority on Popov to use the credit card." And it noted that Citibank wasn't responsible for "obtaining information about the ultimate users of a secondary card." That responsibility rested with the main cardholder.

The court found that, more likely than not, the user who obtained the cash advances was Popov. It found that a third person reasonably could believe that the user in question had the power to act on the authority of the main cardholder.

Gifesman also argued that the Truth In Lending Act states that unauthorized uses can't be charged against a cardholder. But the court noted that the definition of "unauthorized use" excludes any transaction in which the cardholder receives any "benefit." And the $25 a month—though small relative to $50,000 in charges—was a benefit.

Moreover, the court wrote:

> ...we are struck by how little has been disclosed about the transactions underlying this litigation. The record reveals nothing about the nature of the relationship between {Gifesman}, Popov and Kharkover or of the intended use of the card {and} nothing about how the card came to be used in Germany rather than in Russia. In short, the record raises more questions than it answers.

The court concluded that Citibank didn't violate the TILA by shutting down the secondary card and holding Gifesman responsible for the charges.

It rejected Gifesman's claim of **breach of fiduciary duty** because "the parties were not in the kind of relationship in which a fiduciary duty is automatic, such as a partnership or trusteeship." Credit card agreements don't make that kind of relationship.

And it rejected Gifesman's claim of breach of the implied **covenant of good faith** because

> The credit card agreement makes a person who requests and receives a secondary credit card unconditionally responsible...for claims arising out of authorized uses of the secondary card.

Gifesman appealed. The appeals court affirmed the trial court's conclusions.

MARRIAGE AS A RECKONING

Like many people who start small businesses, Amy Lee had financed her start-up with her personal credit cards. When cash flow got tight, she simply accepted another of the pre-approved offers that filled her mailbox on an almost daily basis.

By the time she was able to sell her company to a local competitor, Amy found herself with $40,000 in credit card debt remaining.

She was planning to be married in about a month. The invitations had been sent, and everything was progressing according to schedule.

But Amy's fiance was not pleased about inheriting what he perceived as a lot of debt. The couple lived in a community property state, so he insisted that **she declare bankruptcy** before their wedding day.

Was this a wise move? The bankruptcy definitely affected Amy's credit rating in a dramatic way. And it would stay on her credit report for 10 years. But her husband's credit was so good that the couple was able to purchase two new vehicles based on his credit score alone.

After about four years of rebuilding her credit, Amy's scores also had risen enough for the couple to qualify together for a mortgage at a very good interest rate, and they were able to buy their first home.

SECRETS ARE NOT A GOOD SIGN

Family therapists agree that a successful marriage is based on honest communication. On the other hand, most divorce attorneys will tell you that spouses go to incredible lengths to deceive one another.

Consider one example. John Doe had run up more than $100,000 in credit card debt—and his wife had no clue. Or she didn't, until **a hard-charging collector** suggested that John take out a home equity loan to pay off his substantial debt.

The collector asked to speak with John's wife, to advise her of John's debt situation and explain why it would be wise to take out a home equity loan. John told the collector that he had "taken extraordinary care to keep the amount of his debt concealed from his spouse."

The collector contacted John's wife anyway—and told her everything.

> John sued the collector's employer—a bank specializing in credit cards and mortgages for people with bad credit—for invasion of privacy. He used a phony name to keep his identity out of public records.

The bank never got the Does to take out a home equity loan. But it did succeed in causing "a loss of reputation and stature" with his wife, John alleged in his lawsuit, as well as "marital disharmony and mental anguish."

There can be enough of that in a marriage *without* secret credit card debt.

Did the collector have **a right to tell John's wife** about the credit card debt? The court said *yes*:

> *{John}'s spouse has a "natural and proper interest" in knowing about {his} credit card debt because, depending on the nature of those debts, she is potentially liable.... Also, {his} spouse has a legitimate concern in learning about the credit card debt because {it can} adversely affect her future financial security in the event of divorce....*

As crazy as it seems for, basically, a salesperson to expose secrets about a husband's credit status to his wife, **it's perfectly legal**.

You do have a right to know what your spouse is up to—and your spouse has a right to know what you're up to—especially when it comes to finances.

DIVORCING INTO BANKRUPTCY

Divorce is a major cause of credit-related financial problems in the U.S.

Dorothy Allen never saw her breakup coming. By the time her husband left her to live with a younger woman, he'd racked up $50,000 in credit card debt—much of it spent wining, dining and traveling with the *other* woman.

> Because Dorothy and her husband lived in California, a community property state, she found herself liable for all of that the credit card debt—even though she clearly received no benefit from it.

Dorothy's job as a teacher didn't bring in enough money to cover the mortgage on the house on a golf course that she and her husband had shared, not to mention the credit card bills and the two car payments (one for her car and one for the car her daughter drove while away at college).

Dorothy lost the house and wound up **filing for bankruptcy protection**. Meanwhile, even though her daughter had been making the payments on her car, it was repossessed. Under federal bankruptcy laws, you're only allowed to keep one automobile; both cars had been in Dorothy's name.

In just a matter of months, the family had gone from upper middle class to desperate.

In Dorothy's case, the divorce court never had a chance to divide up the couple's debt. And she and her ex never came to terms about how they would handle it; he simply **abandoned his financial obligations** when he left her and left the state.

A divorce might have helped her. In most cases, if the divorcing spouses cannot come to terms over how to divide their debt themselves, the courts will do so—at the same time they consider all of the other marital property.

The courts have considerable discretion in these cases. All of the debt may be assigned to one spouse, or some may be assigned to each. In determining who gets how much debt, the courts may look at such factors as:

- each spouse's income, employment status and future employment prospects;

- each spouse's spending behavior in the past (especially if one spouse charged most of the credit card debt); and

- each spouse's contribution to paying off debt.

The court also can take into account the division of assets, such as who gets to keep a retirement plan, a house or a car, when apportioning debt.

CREDITORS MAY NOT CARE

It's fairly common for the judge to divide up the debt in a divorce, or assign a particular debt to one spouse or the other. If you're the spouse who did *not* receive this lovely parting gift, you may think you're off the hook for the bill.

But you may not be. If this was a joint account—or if you live in a community property state—you may be liable for the debt, **no matter what the judge said**.

"Your divorce agreement does not change your obligations to your creditors," according to Capital One, a major credit card provider, "and you will be

held accountable should your spouse fail to make a payment on a bill that he/she agreed to pay in your name."

> Unless you and your ex speak honestly about these financial matters, you may never know there's an issue until creditors come after you because your former spouse is late with the payments.

YOU DO HAVE RECOURSE

While your creditors don't care who was assigned a debt in a divorce, the courts certainly do. And you can take your former spouse back to court for not paying a debt that was assigned to him or her.

That's what Faith Geyer did when her ex-husband, Dennis Geyer, failed to pay—as directed—on their joint Chase Bank credit card account.

At the time of the divorce, Faith and Dennis had two credit card accounts with Chase. Dennis had opened an individual account in May 2001; and the couple had opened a joint account several years earlier. At the time of the divorce, Faith had removed Dennis' name from the joint account. But the court assigned the debt to Dennis.

He didn't pay, which is why the former couple wound up back in court. Dennis insisted that he shouldn't have to pay for debt he did not create.

But the court was clear on this matter:

The trial court is provided with broad discretion in deciding what is equitable upon the facts and circumstances of each case.

While Dennis did not have to pay for any debt Faith amassed after the divorce, he was ordered to pay the $1,227.75 that had been the outstanding balance at the time of the decision.

A BETTER WAY TO BREAK UP

The best way to avoid ugly surprises, like overdue debt, is to separate your credit when you divorce— or, better yet, **as soon as you separate**.

There are several ways you can do this. For example, you may be able to convert joint accounts to individual accounts in one spouse's name or the other.

> **Some creditors will convert accounts, others will not. If not, you may have to close the joint accounts and apply for new individual accounts.**

When it comes to a mortgage or a home equity loan, you probably will have to **refinance the loan** to remove one spouse's name—and responsibility— from this major asset.

It's especially important to keep payments current on joint accounts before you are able to separate your credit. Otherwise, you risk adversely affecting both your and your ex's credit, which will make the future cost of borrowing higher for each of you.

Generally, it's better to refinance existing debts than to divide them. You may want to get individual consolidation loans, so you can each pay off your share of the joint debt and start fresh with individual accounts.

If the divorce isn't amicable, there are other steps you can take. You can:

- close joint accounts unilaterally;

- remove your spouse as an authorized user from your accounts; and

- notify joint creditors in writing that your spouse may be racking up debts, and state that you are not responsible for those debts.

That last step won't prevent creditors from coming after you in the event your spouse doesn't pay. But it will establish that you tried to behave in a responsible manner.

ESTABLISH YOUR OWN CREDIT

If you see divorce clouds on the horizon, or if you have just separated from your spouse, you'll want to establish credit in your own name—especially if that spouse has money problems.

In fact, it's a good idea to establish **your own credit**, even if your marriage is strong. In some cases, the unexpected death of a good spouse can cause just as much havoc as a divorce from a bad one.

- Open your own bank account. This will be an account that your spouse does not have access to.

- Open your own individual credit card accounts.

- Get a copy of each of your credit reports, so you know where you stand individually, and so you know how much of your credit history overlaps with your spouse's.

HELPING FAMILY MEMBERS

Invariably, at some point, a family member will ask you for financial help. This might be a sibling asking you to co-sign for car loan...a child asking for help buying a first house...or a parent desperate to get out of a bad debt.

The consensus opinion—with regard to protecting your own credit—on helping family members: Lend cash, if you can. Even consider borrowing on your own in order to lend. But don't co-sign.

This advice runs against what's usually the easiest thing to do. Credit card companies, auto finance companies and mortgagers all make it **easy for family members to co-sign** on loans. But co-signing makes the co-signer fully liable for the debts. This is the a **serious risk to your credit**.

The challenge to making a good personal loan is balancing the personal and financial interests. No matter what a contract says, the ultimate security for most personal loans is your friendship with or family ties to the borrower. **You count on these ties** to compel the borrower to make the interest payments and return the principal.

A good approach is to ask the friend or family borrower questions that give some **terms to the transaction**—and give you information on which to base your decision. These questions should include:

- **How much** do you want to borrow?

- **How long** do you want to borrow the money?

- What—exactly—are you going to **do with the money?**

- How do you **plan to repay** the loan?

- Do you have a **backup plan**, in case your first plan doesn't work?

- Are there any **benchmarks or guidelines** that will measure your ability to repay while you have the loan?

- Do you have any **collateral** to secure the loan?

- What **other lenders** have you approached?

- If this loan doesn't perform as we plan, **how will you react** when we see each other socially?

The answers to each of these questions tell something about the borrower and the loan.

The main relevance of the **how much** question is how realistic the borrower is about his or her needs. Does your cousin the school teacher need $10,000 to add to the $20,000 in cash she's saved to put down on a house? That's a rational request. Does she want to borrow $150,000 to move into a swanky neighborhood? She may be confused about money and earning power.

> There are no simple guidelines for determining how much money you should loan someone. From a risk management perspective, it's not a good idea to concentrate more than 10 percent of your assets in any single investment. And a loan...even a personal loan...is an investment. But, in cases of family businesses or some real estate investments, it might make sense to make a larger loan.

The **how long** and **how much interest** questions give you some idea about how grounded the borrower is in reality. You don't want to hear things like "I don't know" or "Well, as long as I can keep it." These suggest that the borrower isn't treating the cost of the loan seriously—which suggests he's not thinking seriously about repaying it.

Like any financing, a personal loan should charge less interest as its term gets shorter. You might loan a family member money for a few weeks interest-free; but a 10-year loan needs to pay interest.

The **what are you going to do** question and the **how will you repay** questions should give you some insight into the borrower's mind set. You don't want to hear a tearful admission of drug addiction, adultery or looming bankruptcy. **Personal crises** can mean that you're throwing good money after bad.

Keep in mind, if a friend or family member is asking you—instead of a bank—for a loan, there's probably *some* kind of problem afoot.

More broadly, you can usually organize needs into two rough categories:

- rectifying trouble situations, and
- pursuing opportunities.

Loans made to rectify trouble are more likely to cause problems. The borrower may simply be swapping existing troubles for...troubles with you.

> Crafty or desperate borrowers will sometimes describe a rectify-trouble loan as a pursue-opportunity loan. That's why you should ask a lot of detailed questions about any use of the money. Look for any hazy lack of detail.

A business/personal use distinction may also be useful to know. Many lenders believe that in family money situations, the more business-related the loan, **the more likely you'll get your money back** in a timely manner.

If the borrower has been thinking about using the loan to start a business, he or she should have already worked out the **benchmarks of performance** that will measure ability to repay. If the benchmarks aren't there, the plan may not be that strong.

With a business, the need may be genuine. Banks and other commercial finance sources provide capital for business. But new businesses—and small businesses, even when they aren't new—usually have a tough time tapping into this source of money, so owners approach their family members.

THE PROMISSORY NOTE

If you're ready to make the loan to a friend, acquaintance or family member, the formal document needs to be made. A clearly-written promissory note is a contract and should be fully enforceable in any court or arbitration hearing.

> **And, even more important, a promissory note clearly distinguishes your role as a lender and not a partner, trustee or co-signer.**

The promissory note should state:

- the date the loan was made;
- the name and address of the lender;
- the name and address of the borrower;

- the city and state in which the loan was made;

- the amount of money loaned;

- the due (or maturity) date when the loan is to be repaid;

- any conditions under which the loan can be called for repayment before its due date;

- the schedule of any payments to be made during the term of the loan;

- the nature of the payments (interest only, interest-plus-principal, balloon);

- the total amount due, including interest and principal;

- whether the note is transferrable and under what conditions it can be.

CONCLUSION

Your spouse is your only **true partner** when it comes to your personal credit score. Whether or not you live in a community property state, after a few years of marriage, your credit score and your spouse's will start to mirror each other.

Keep this in mind when you marry: Emotional or personal problems aren't always a sign of financial troubles...but they can **suggest general instability**. And divorce is one of the major causes of damaged credit in the U.S.

For these reasons, even if your marriage is blissful, it's a good idea for both spouses to keep some separate credit and bank accounts. But separate accounts shouldn't mean lots of money secrets. If you're married, be prepared to face questions; and be prepared to ask questions. It's amazing what can turn up in a collection call—things like **gambling debts** and **extramarital affairs**.

Other family members and friends will only affect your credit **as much as you let them**—by co-signing loans, making them authorized users on credit cards or becoming their partners in business.

If you have a some financial resources and a strong credit score, the best strategy for helping family will probably be to loan as much cash as you can. But avoid co-signing for loans or making partnerships.

11

IMPROVING YOUR CREDIT SCORE

Whether you've had credit problems in the past or you're simply aiming to get better interest rates in the future, there are always **steps you can take to improve your credit score**.

And you can take many of these steps by yourself—without paying someone else to help. Since the early 1990s, thousands of "credit repair" firms have come into being. Some are legitimate…many are crooked. You need to proceed carefully when working with these outfits.

> **However you proceed, don't believe the credit repair agencies who will tell you they can repair your credit in a matter of weeks. Coming back from the credit-damned takes time, often in the neighborhood of one to two years.**

It is true that some credit repairs will show up faster than others. Credit scores are fluid numbers that

change all the time, as the information in your credit report changes. However, Experian notes, "Most credit scores do not change more than 30 points in a quarter."

So, you can do the math on this: If your credit score is in the low 500s and you want to get it into the mid 600s (the range most lenders consider "good" credit), it will take about **a year of making smart repairs**. As long as you don't expect your credit score to shoot up from the 400-point range to the 700s overnight, you won't be disappointed.

And here's the best part: Once you've invested the time and effort, improving your credit ratings will pay off in serious cost-of-credit savings—as well as new opportunities.

STEP 1: GET YOUR REPORTS

If you haven't done so already, the first step in improving your credit ratings is to get a copy of each of your credit reports.

As we've mentioned before, the majority of reports have at least one error, however small.

And if you find something substantial that's both wrong and negative, it can help your score leap upward right away. You're looking for things like:

- payments that the report shows as late, but which you actually paid on time;
- accounts that don't even belong to you;

- debts that you paid off, but which still show an outstanding balance; and

- charge-offs, late payments and other "black marks" that should have come off your report by now, if it's been more than seven years (or more than 10 years for a bankruptcy).

If you have applied for credit recently and you were turned down, pay close attention to the **reason stated on the rejection** letter. By law, lenders must tell you what piece (or pieces) of information in your credit report triggered the denial of credit.

This can be a vital clue in turning around your score. And it can be a tip-off that something is wrong on your credit report.

STEP 2: PAY BILLS ON TIME

Once you've made sure your credit reports are correct, the next step toward credit repair is to start paying each and **every bill on time**. Even if you're just paying just the minimum amounts due, pay those at least. And right on time.

Just as delinquent payments and missed payments have a negative impact on your score, regular on-time payments have a big positive impact.

Simply put, the longer you pay your bills on time, the higher your credit score.

This is a relatively slow route to improved credit ratings, but it's the one that works in the long run.

Creditors place a lot of value on consistent behavior. So if you do wind up being late on one payment down the road, having established a history of paying on time will make all the difference.

STEP 3: KEEP USING CREDIT

Whether they've had credit problems in the past or they simply don't trust credit, many people think they're better off **buying everything with cash**. But when it comes to credit ratings, this couldn't be further from the truth.

Whether you've had a bankruptcy or some other tough financial situation, lenders want to see that you've been "rehabilitated." They want to see that you've learned how to handle credit responsibly.

> **If you haven't reestablished credit, you're deemed just as risky as someone on the brink of collapse.**

So, if you're looking to improve your credit ratings, don't go from bad to bad. Use credit. Just use it responsibly.

STEP 4: PAY DOWN BALANCES

Naturally, if you have several credit cards and they're all maxed out, that makes lenders uneasy—which is reflected in your credit scores.

One of the faster ways to improve your credit score is to pay down the balances on your credit cards.

Lenders like to see a nice ratio between the amount of credit you have available on your credit cards and the outstanding balances on those cards, also known as your **utilization ratio**.

As a first step, aim to reduce your balances to 75 percent of your total available credit. Then, over time, bring that percentage even lower.

Nobody knows what the perfect number is. Some experts say lenders would like your credit card balances to be about 30 percent of your available credit, or even as low as 20 percent. Other experts say 50 percent is okay.

Whatever a particular lender's preferred number, all lenders want to see that you're making progress on **paying down your total credit card debt**, not just moving it around from card to card.

But don't go crazy. According to Consumer Credit Counseling Service (CCCS), a nonprofit community service organization that provides financial education to consumers (and which does receive some funding from credit card companies):

> *A good rule of thumb is to allow no more than 30 percent of your take-home pay for housing, and not more than 20 percent for debt repayment, including your vehicle payment.*

STEP 5: KEEP ACCOUNTS ACTIVE

Some people will tell you to get rid of any credit cards you aren't currently using. And if you're a shopaholic who can't have a credit card without maxing it out, that's probably good advice.

> Fair, Isaac & Co. and other credit rating experts point out that if you want to improve your credit scores, think twice before you close out an account.

Instead, the best goal is to get your outstanding balances to about 30 to 50 percent of your total available credit.

For example, let's say you're thinking about closing an account with a $10,000 credit limit. Right now, your outstanding balance on your two other cards is $10,000. The credit limits on those two cards adds up to $15,000. If you get rid of the card with the $10,000 credit limit, then your ratio of credit to debt is 67 percent. If you keep the card, your ratio is 40 percent.

You can make the dramatic move of cutting up the card—but **keep the account active**. By keeping it, you look better on paper. You look further away from maxing out your existing credit cards. And that translates into a better credit score.

But you may not want to keep that third card with a zero balance. Some experts say lenders would rather see three credit cards at 20 percent of their limit

than two credit cards with a zero balance and one at 80 percent of its limit.

Of course, paying down your balances will have a much better effect on your score than just moving those balances around. But spreading out the debt can have a positive effect.

STEP 6: AVOID NEW CREDIT

The number of **hard inquiries** on your credit reports does effect your credit rating.

So, if you're trying to improve your credit, don't apply for more credit cards than you need—even if they do want to give you a free toaster oven just for filling out the application form.

A large number of credit card inquiries makes lenders think you're planning to run up a lot of debt. Plus, they can't tell how many of those accounts you've actually opened, since there's a delay before new accounts show up on your credit history.

> **Another consideration:** Having new accounts will lower the average age of your accounts. The longer your credit history, the better your score.

OTHER STEPS

Most people only need two or three credit cards; so that's a number to aim for, if you currently have

more accounts. Just remember you don't have to get there overnight.

> **It can improve your credit score to get rid of extra accounts. But, again, they key is to consider your utilization ratio before you get rid of any credit cards. Don't close two and leave two maxed out.**

For the best effect on your credit ratings, if you are going to close out more than one account, **do it slowly** over a period of several months. When you've paid down your outstanding balances enough to consider getting rid of one of your cards, don't close out the account you've had the longest. Even if it has the highest interest rate of all of them, keep the card you've had for the longest time.

Lenders like to see a long credit history. So, if you close the one account you've had for 20 years and keep the two you got within the last three years, all of a sudden you look like a much **newer borrower**. This will adversely affect your credit score.

Also, check your credit reports after you have closed the accounts to make sure that they were reported as "closed by consumer." This will have the most positive effect on your credit rating.

SHOW STABILITY

Some credit scoring models—such as those used by mortgage lenders—also look for stability in your

history. They can consider things like how long you've lived at your current address, and how long you've held your current job. Some models also factor in whether you own or rent your home.

> **You shouldn't stay in a bad job or substandard living conditions just to improve your stability score. But you may want to consider limiting these sorts of changes right before you refinance your house or apply for a large chunk of credit.**

You also can use stability concerns to improve your credit score. For example, when you look over your credit reports, you may notice that one or more of your longtime **satisfied creditors** do not report information to a credit bureau. Many creditors do not, including some (but not all) of the:

- department stores;
- gasoline credit card providers;
- travel and entertainment cards;
- local banks; and
- credit unions.

If you have a good history with one of these companies and you can convince it to provide your account information and payment history to the credit bureaus, it can have a positive effect on your credit ratings. **Give this creditor a call.**

Another way to show stability and increase potential lender confidence is to open a **savings account**

at your bank and keep putting at least some money into it. This shows discipline, and it also shows that you have some funds on hand to repay debts.

ADVANCED TACTICS

If you're really trying to improve your credit rating in a hurry, there are some other techniques you can use. For example, your credit reports will reveal the date each month on which your creditors report your information to the credit bureaus.

Most creditors provide this information just once a month, and the odds are that the date does not correspond with your payment due date. So, if you want to pay off a balance and have it show up as paid ASAP on your credit report, you need to make sure the payment reaches the creditor in time to be processed before that company's **reporting date**.

In addition to finessing your payment dates, you also may want to consider **rapid rescoring**. This is useful if you're in the middle of trying to qualify for a loan and you need your credit score updated right away—as fast as within 72 hours.

> **You can't take care of this one yourself. You will need to work with a lender that has a relationship with a rapid rescoring service.**

But if, for example, you just paid off a big out-standing balance on a credit card or you just paid

off a car loan—or if there's a major error on your credit report—rapid rescoring will make sure your credit score reflects the new information quickly.

However, you will have to pay for this service, usually around $50 for each account that needs to be updated for the new rescoring. Still, the $50 or $100 you pay can be well worth it to save tens of thousands of dollars in interest over the course of a 30-year home loan.

PLAYING WITH THE NUMBERS

If you want to see how certain actions on your part will affect your credit score (both directly and indirectly), the best way is to use a **credit score simulator**. There are many of these; but probably the best-known simulator is the one Fair, Isaac & Co. provides when you purchase a credit score from it's Internet Web site, www.myfico.com.

> With these simulators, you can see how paying off an auto loan will affect your score, compared with taking that same money to pay down credit card debt or pay off a student loan. Or you can see how missing several payments will affect you.

You also can see how opening another credit account will affect your score. Or you can see how much your ratings will improve once a bankruptcy or a late payment comes off your credit reports.

TIME HEALS ALL WOUNDS

As we've mentioned before, the passing of **time will erase some of the black marks** on a credit report.

If you have declared bankruptcy, after 10 years, it will disappear from your credit report. And many mortgage lenders will overlook a bankruptcy when making lending decisions after seven years.

Seven years is also the magic time period for late payments and charge-offs to disappear from your credit history.

However, according to the Federal Trade Commission (FTC), there are certain exceptions:

- Credit information reported in response to an application for a job with a salary of more than $75,000 has no time limit.

- Information about criminal convictions has no time limit.

- Credit information reported because of an application for more than $150,000 worth of credit or life insurance has no time limit.

- Default information concerning U.S. Government insured or guaranteed student loans can be reported for seven years after certain guarantor actions.

- Information about a lawsuit or an unpaid judgment against you can be reported for seven years or until the stat-

ute of limitations runs out, whichever
is longer.

The seven-year clock starts ticking **the date the
"event" took place**, whether the event is a late
payment or your account being turned over to a
collections agency.

So, let's say you were late on a payment in March,
but then you caught up in April. The report of a
late payment can remain on your credit history until
seven years from that fateful March.

ALTERNATIVES TO WAITING

While time will heal your credit report, there are
ways to improve your credit ratings without wait-
ing (assuming you've changed your ways).

Note: **If it has been nearly seven years** since you
had any late payments or charge-offs, you probably
are better off waiting out the time until your credit
score automatically increases.

But, **if your credit problems are more recent,**
you can take steps to have **charge-offs reclassi-
fied** as something more palatable to lenders.

Keep in mind that, in order to accomplish this re-
classification, you will need to pay off the debt in
question—or at least pay part of the debt, if you are
able to negotiate a settlement.

Whatever you do, *don't* just send in the money owed. Follow the process we outline below, so you get the most benefit, in terms of your credit report and credit scores, from the dollars you fork over.

If the account was turned over to a collection agency, you will want to negotiate with the collection agency directly.

You have two goals in this process, as far as your credit reports are concerned:

- to have the collection agency remove its listing from your credit report entirely; and

- to have the original creditor report your account to the consumer reporting agencies as "Paid as Agreed," or "Account Closed/Paid as Agreed."

This is the outcome that will have a profoundly positive effect on your credit report. Any other outcome is not nearly as desirable.

Don't send any money until you get these agreements in writing. Period. A verbal agreement is not sufficient. And, once they have your money, your ability to negotiate is over.

You should do all of your communicating with the collection agency and the original creditor in writing, and ask that they respond in writing, as well. When you mail a letter to either company, also be

sure to send it certified and get a return receipt. And save copies of every letter you send. The idea is to create a paper trail.

When you are negotiating with these companies, try to remember that this is not about morals or ethics or whether you're a good or evil person. Some collectors are trained to use language about "ethics" and "shame" in order to convince people to pay larger settlement amounts. Your arguments will need to focus on dollars and sense—business sense—in order to persuade these companies to accept as little as needed to report the debt "paid as agreed."

If you cannot get the original creditor to report your debt "paid as agreed," you may want to accept a notation of "Paid" or even "Settled." However, these are not as good for your credit score overall.

There is some risk in initiating this process. The creditor may not agree to do anything you request. Instead—knowing that you have at least some money to repay your debt—it may take you to court, get a judgment against you and then collect not only the debt, but also interest, court costs and legal fees.

"NEW CREDIT IDENTITY"

Stay away from credit repair outfits that talk about "recreating" you with a name change or new Social Security number. These tactics are always shady...and, sometimes, they're illegal.

Crooked credit repair outfits may also tell you that you won't be able to get any credit for 10 years after you file for bankruptcy (which is a lie).

Then they tell you that, for a fee, they can **create a new credit identity** for you. If you ante up, they typically will direct you to contact the Internal Revenue Service (IRS) and apply for an Employer Identification Number (EIN)—the identifying number that businesses use much in the way individuals use their Social Security number. The credit repair bandit then will tell you to:

- use the EIN instead of your Social Security number to apply for credit;

- use a new mailing address; and

- come up with new credit references.

There's one problem with this idea: It's illegal. According to the Federal Trade Commission:

> *It is a federal crime to make any false statements on a loan or credit application. The credit repair company may advise you to do just that. It is a federal crime to misrepresent your Social Security number. It also is a federal crime to obtain an EIN from the IRS under false pretenses. Further, you could be charged with mail or wire fraud if you use the mail or the telephone to apply for credit and provide false information.*

WEASELS ON BOTH SIDES

Most collection agencies and law firms that specialize in collections justify their efforts as the best way

for lenders to follow consumer protection laws like the Truth in Lending Act and the Fair Credit and Recovery Act. But their efforts often appear more intimidating than helpful to the debtors. And there are collectors, debt counsellors and attorneys who make use of this impression.

The January 1999 New York state court decision *Citibank (South Dakota) v. Lori J. DiNorma* discussed some aggressive collections tactics and shady debt-reduction tactics.

DiNorma owed several thousand dollars to Citibank from credit cards that he'd used. The bank started aggressive collection actions, so he hired attorney Andrew Capoccia—who operated "debt reduction centers" throughout New York state.

Capoccia advertised to people with severe financial problems, luring them with promises of significant reductions in debt while avoiding bankruptcy.

> Once enrolled in a debt reduction program, Capoccia's clients were instructed to stop paying their debts and, instead, make monthly payments to an escrow account that Capoccia controlled. Before any debts were paid, Capoccia's fees were deducted from this account. These fees generally accounted for what would have been several months of debt reduction payments by the client.

DiNorma followed these rules. And Citibank sued him. The court was quick to notice a trend:

> *This court has received no fewer than seven cases in which Mr. Capoccia represents the defendant and in which the plaintiff is Citibank. All seven relate virtually identical facts, a defendant's default in meeting credit card obligations. …With minor variations in wording {the filings} are identical. The affirmative defenses are the alleged failure to state a cause of action, a claim that the credit card agreement is unconscionable, and a supposed failure to comply with {New York state law}. The two counterclaims are that Citibank violated the truth in lending act and that the agreement is not in plain language….*

The court didn't see much merit in Capoccia's legal theories.

Citibank moved to dismiss the defenses and asked the court sanctions on Capoccia's firm for **frivolous defenses**. But the bank's lawyers didn't seem any more professional than Capoccia. The court noted:

> *In attempting to bolster its sanctions argument, the bank has presented seven identical and identically voluminous sets of supporting papers, each a hodgepodge of earlier decisions by various courts, copies of pleadings by the Capoccia firm in other cases, and similar material, all intended—no doubt—to paint the Capoccia firm as engaging in a habitual course of unreasoned and unjustified obstructionism.*

Not to be outdone, Capoccia's firm responded with similarly **repetitive papers**, showing that it had obtained settlements on behalf of many of its clients and had at times prevailed in courts…as well as been criticized there.

Capoccia argued that the bank conned consumers into taking on obligations they didn't understand and couldn't pay. Then it hid behind lawyers. He requested sanctions against Citibank for bringing frivolous motions...for sanctions.

The court wasn't impressed with all of the paper:

> *Conspicuously absent from the papers is any consideration of the facts of the various actions that are supposedly before the court. ...The bank has drafted its papers not to prosecute the cases against these debtors, but to show that the Capoccia firm does nothing more than raise bogus defenses and counterclaims in order to frustrate and stall legitimate collection efforts, with an eye to wearing out creditors and obtaining settlements....*

This may have been a cagey strategy for Capoccia; but his firm applied it in such a cookie-cutter way for all clients that it backfired on all of them.

One credit card default may resemble another, as mortgage foreclosures do; but the resolution of the individual problems will be different for each person. Beware of any credit repair outfit that makes sweeping promises about "situations like yours" before they've looked over your credit history.

QUICK POINTS TO REMEMBER

Another sign that you're dealing with a rip-off artist: The company requires an up-front payment.

Under the federal **Credit Repair Organizations Act**, it is illegal for credit repair companies to charge you until after they have performed their services.

By law, **credit repair companies** also must:

- inform you of your legal rights;

- give you a written contract that details:

- the services to be performed;

- how long it's going to take to get results;

- the total cost to you;

- any guarantees that the company offers; and

- the fact that you have three days in which to cancel the contract at no cost to you.

CONCLUSION

Experts agree that the best way to improve your credit scores is to pay your bills on time, pay down your outstanding balances on credit cards and avoid taking on new debt.

Doing this shows that you use credit conservatively. And that's something lenders appreciate. After all, they tend to be conservative themselves.

MORTGAGES AND
CAR LOANS

Your credit score really comes into play when you're in the market for a **home or new vehicle**. Since the 1980s, lenders have become more sophisticated about using credit scores to evaluate borrowers. This means both good and bad things for you.

The **good news** is that an increasingly national lending market means that there are programs for people with even checkered credit histories to get home or car loans. Of course, if you have poor credit, you're going to pay a lot in interest and fees.

The **bad news** is that lenders are more demanding than ever about personal information from borrowers and—in a cruel irony—the lending process has become a lot *less* personal than it used to be. Even local banks use mathematical formulas to decide whether they will lend money…and at what cost.

The terms and conditions offered by secured lenders—banks, credit unions and finance companies who lend on things like car and home purchases—vary widely. In this chapter, we'll consider the details.

As in any market, some lenders offer better rates than others. Even as lenders have become more scientific, **the formulas they use can be quite different**. Different lenders use different credit score ranges when determining whether to lend to you...and which interest rate to offer. If your credit score is 718, you may be offered the best rate by one company and the second-best by another.

There are also a lot of variables to consider, including—and extending far beyond—the interest rate.

HOME MORTGAGE LOANS

A home loan typically is the largest debt a consumer has. Choosing a mortgage is a big decision, and one that must consider **many variables**.

One of the biggest mistakes home buyers, particularly first-time home buyers, make is **underestimating the expenses** related to owning a home—including maintenance costs, repair costs, property taxes and homeowners insurance. That can lead to credit problems, after you've gotten a mortgage.

> **The taxes and insurance on a home can be especially expensive. And the cost is magnified is you borrow heavily to buy the house.**

Still, owning a home is a good goal—both personally and financially. People rarely lose money owning a home...and usually make money doing so.

Home ownership also tends to improve people's financial circumstances and attitudes, generally.

Once you've analyzed all of the costs associated with your new home, as well as your other monthly expenses, you should have an idea how much you can afford to pay each month for your mortgage. At this point, you're ready to talk to potential lenders—before you start shopping for a home.

QUALIFYING RATIOS

While you may look at all of the expenses related to owning a home, lenders will look at slightly different criteria, known as **qualifying ratios**. Basically, they want to know what percentage of your income you will be spending on monthly payment.

The front-end ratio, or **front ratio**, compares your monthly pre-tax income with your house payment. Most lenders want to see a front-end ratio of 28 or lower; this means you'll spend no more than 28 percent of your monthly gross on your mortgage.

The other ratio that lenders look at is the back-end ratio, or **back ratio**. This calculates how much of your pre-tax income will go toward your house payment, plus all of your other monthly debt payments—such as auto loans, credit cards, etc.

Not so long ago, a back-end ratio of 36 was the limit, but lenders have loosened their restrictions on this number somewhat.

It can be useful to **figure out these numbers yourself** and see if the house payment you have in mind may actually cause you undue financial risk.

You will definitely want to contact more than one potential lender, so you can compare interest rates and all the other terms associated with a loan.

To get started, you may want to research mortgages through:

- your bank or credit union;
- any of the thousands of other banks that offer mortgages;
- on-line lenders; and
- mortgage brokers.

Many consumers choose to shop through a mortgage broker, because brokers have access to loans from a range of banks.

Rather than dealing with each bank yourself, you can save time and effort—and reduce the number of inquiries that show up on your credit report— by filling out one application with **a mortgage broker**. A good broker will find you the best deal, given the property, your preferences and your credit score.

> **The broker makes his money by adding a broker premium to the cost of the loan, which he gets at a discounted rate. It's essentially like buying anything at retail: The broker gets the loan at wholesale, then marks it up before selling it to you.**

Whether you meet with your bank or a mortgage broker or go through an on-line lending service, your goal remains the same: to get a **pre-approval letter** before you start house hunting.

> **The pre-approval letter estimates how much you will be able to borrow, based on current interest rates and a quick look at your credit history. In some markets, where homes are selling quickly, your real estate agent may refuse to write an offer for you if you aren't at least pre-qualified by a lender.**

A **pre-qualification letter** is similar to pre-approval letter, but a "pre-qual" is nonbinding. If you're buying in a hot real estate market, a pre-approval letter is better...and may be necessary.

WORKING WITH A LOAN BROKER

The September 2003 Michigan state appeals court decision *Robert H. Roether v. Worldwide Financial Services* offers an example of how important pre-approval letters can be. And how much trouble can come when a borrower doesn't manage his credit well.

Robert Roether and his wife lived in West Bloomfield, Michigan, and wanted to buy a condominium in nearby Ann Arbor. Roether knew Howard Eisenshtadt, a mortgage broker with Worldwide Financial, socially; their wives worked together. Roether contacted Eisenshtadt in April 2000 to help get a mortgage for the condo.

Eisenshtadt gave the Roethers and their real estate agent a preapproval letter for a loan of $225,000 from Worldwide Financial. According to the language of the letter, it was a conditional offer of preapproval for a loan and was **not a contract or actual approval** for a specific loan.

Eisenshtadt claimed he issued the certificate because he knew the Roethers well and knew Robert Roether was an attorney in solo practice.

Roether's version was that Eisenshtadt had issued the preapproval letter on the basis of a credit report and not on merely on their social relationship. And Roether pointed out that his credit report was pulled the day before the certificate was issued.

When Eisenshtadt reviewed the Roethers' credit histories, he realized **there were going to be problems** making the loan. The Roethers had been a late on mortgage payments several times; and they owed a lot of money to other creditors (including large balances with several credit card companies).

The Roethers disputed Eisenshtadt's characterization of their credit and claimed that their financial situation qualified them for a mortgage loan of $265,000 *in addition to* their West Bloomfield mortgages of $250,000.

Worldwide Financial didn't agree. Eisenshtadt told the Roethers that they would have to use the "**stated income**" **method** of applying for a mortgage, which required a larger down payment and meant a higher interest rate. He suggested that they make the application only in Robert's name because a lot of the

credit card debt was in Barbara's. And, even with these changes, Eisenshtadt suggested that Robert pay off some of *his* credit card debt to improve his credit score.

Eisenshtadt and Roether agreed that the Roethers should consolidate the two mortgages on their West Bloomfield home in a refinance package—and use some of their equity to **pay off certain creditors**, a list of which Eisenshtadt gave Roether.

> **While they were taking these various steps to clean up their credit, the Roethers signed a contract to purchase the condo in Ann Arbor. Roether claimed he faxed Eisenshtadt a copy of the contract on the condo on April 14, 2000. Eisenshtadt didn't recall receiving anything like that so early on.**

The Roethers closed on their consolidation refi on April 28, and received the resulting cash from Eisenshtadt personally on May 3. When he gave the Roethers the money, Eisenshtadt **repeated the list of creditors** that needed to be paid with the funds in order to raise their credit scores.

Eisenshtadt claimed that he first learned about the contract on the Ann Arbor condo on May 9. He began the loan process but didn't send the application until nine days later. In the meantime, he got an updated copy of the Roethers' credit report. It showed that they had used the funds from the refi to pay off **Barbara's individual debt** instead of the list of creditors suggested by Eisenshtadt.

The Roethers were looking for a 90 percent loan on the Ann Arbor condo. In Eisenshtadt's opinion, it was nearly **impossible to find an investor for that loan** with the Roethers' credit scores. He mentioned his concerns to Roether, who said he could raise his down payment to 15 percent. Eisenshtadt still couldn't find a lender for the Roethers in time to complete their contract. The offer fell apart and the Ann Arbor condo was sold to someone else.

Roether sued Eisenshtadt and Worldwide Financial, alleging claims of misrepresentation, breach of fiduciary duty, Michigan Consumer Protection Act (MCPA) violations and breach of contract.

The trial court didn't think much of Roether's case. It ruled that Eisenshtadt's "preapproval certificate" did not contain a promise for a specific loan in part because no terms of the loan were specified in the certificate. And it rejected Roether's other claims.

He appealed. But the appeals court didn't think any better of his suit. It wrote:

> *Our review of the certificate comports with the trial court's reasoning. The plain language of the certificate itself demonstrates it was not a contract for a loan; instead, it was a conditional offer of a loan.*

The appeals also rejected his other claims.

It's important to understand the limits on a prequalification letter. You may need to **find a better loan quickly**, if your broker can't come through with the terms he or she mentions at first.

HOME LOAN MECHANICS

Before you can be pre-approved for a mortgage, you'll have to answer a whole lot of questions about the type of home loan you would like.

Here are the major variables you'll want to consider when you're comparison shopping:

- interest rates, including whether they are fixed or adjustable;
- points;
- amount of the loan;
- the amount of your down payment;
- closing costs;
- how much information you provide;
- the length of the loan; and
- whether there's a balloon payment.

The **interest rate** you are quoted by a lender will have as much to do with your credit history as with the prime rate. Personal factors that influence the interest rate of a mortgage include:

- credit scores;
- the type of property (a single-family home, a mobile home, etc.);
- the amount of your down payment; and
- the size of the loan.

You also will be able to choose between an interest rate that is fixed and one that's adjustable.

With a fixed rate mortgage, you know exactly what you are going to pay each month for the life of the loan. It's **the safest kind of home loan** to have. If interest rates drop dramatically, you can always refinance to get a better rate; if interest rates go up, you'll be smart for having locked in a lower rate.

With an adjustable rate mortgage (ARM), your monthly payments can change over time.

Most adjustable rate mortgages **start out with a fixed rate** that typically is lower than the going rate for an fixed-rate. Common ARMs have a fixed rate for one, three, five, seven or 10 years. After that, the interest rate will be adjusted each year.

When you're shopping for mortgages, you'll see adjustable loans listed as 1/1, 3/1, 5/1 and so on. The first number indicates how many years the initial fixed rate will last. The second number tells you how often the interest rate will be adjusted thereafter (virtually always a 1 to indicate an annual adjustment).

> **If you think you're going to sell a house in five or seven years anyway, and you expect interest rates to rise, then you're probably better off getting a 5/ 1 or 7/1 ARM. That's because the initial interest rate likely will be lower than the rate for a 30-year fixed loan, and you'll be selling the house before your interest rate changes.**

In addition to the basic fixed or adjustable mortgage choices, there are some other options.

For example, a **step-rate mortgage** starts out with a fixed rate, usually for the first two years, then the interest rate rises.

And then there's the **interest rate buy-down** plan. In this case, you can pay a fee to get a lower rate for a set period, usually two years. Then the interest rate rises to its normal fixed level.

AMORTIZATION

Ordinarily, when you get a mortgage, your monthly payments are a combination of interest and principal. Principal is the amount you actually borrowed.

> **In the early years of a 30-year mortgage, you pay almost entirely interest—which gives you a nice big income tax write-off.**

As time goes on, depending on your loan's **amortization schedule**, more of your payment applies to the principal.

However, many consumers have opted to take a different route. In an effort to keep their monthly payments lower, many people take out **an interest-only loan**. In this case, you do not pay down the balance on the loan at all.

If the real estate market is flat in your area, then the big drawback to an interest-only loan is the fact that you **do not build up equity** in the house. How-

ever, in areas where real estate values are climbing rapidly, you can build up equity simply through your home's appreciation.

PAYING POINTS

Some lenders advertise "no points" when trying to get you to apply for a loan. The points in question are actually a percentage point of the amount of the loan. In other words, each point equals 1 percent.

Origination points are a fee that lenders charge to recoup some of their expenses in making the loan—and to make some profit, too. Ideally, you want to avoid paying any origination points.

> Lenders consider your credit score when deciding whether to charge origination points. If you have a high credit score—over 700 in the FICO system—you probably won't have to pay these points. If your score is in the 600s, you may have to pay one or two; if your score is in the 500s, you may have to pay three or more.

Discount points are another matter. In this case, you agree to pay one or more points up front in order to get a better interest rate on your loan. You may even be able to get an interest rate that is below the going rate this way (sometimes called a buydown mortgage). Discount points aren't tied directly to your credit score.

To determine whether to pay discount points, you'll need to get the lender to quote the loan **at both interest rates**, then see how much you save each month and over the life of the loan. Consider how long you plan to stay in the house; you may not be there long enough to recoup your up-front expense.

You also need to consider whether you can afford to pay 1 or 2 percent of your mortgage amount, on top of the down payment, closing costs and fees.

AMOUNT OF THE LOAN

The amount of money you need to borrow can have a profound effect on the interest rate in question.

That's because there are two kinds of mortgages: **conventional and jumbo**. Conventional loans can be sold in the government-supported wholesale aftermarket. This makes the loan less risky for the lender—regardless of your credit situation.

> **One of the main guidelines for a conventional mortgage is that it can't be too large. In 2004, it couldn't be more than $333,700 ($500,550 in Alaska, Hawaii and the U.S. Virgin Islands).**

If your home loan is larger than the conventional limit, you'll be shopping for a jumbo loan—and you'll be paying a higher interest rate. Also, your credit score will play **a bigger part** in the bank's decision whether to make the loan.

The amount of the loan is important for another reason, too: Lenders look at the home's **loan-to-value (LTV) ratio** when making decisions.

Most lenders have pretty strict guidelines, when it comes to loan-to-value ratio—but they can vary from lender to lender. A maximum LTV ratio of 80 is pretty common. (There are lenders that will loan 90, 100 and even 125 percent of the home's value, in some cases. You have to have a relatively high credit score for these loans and, even then, they come with very **high interest rates**.)

> **If you're planning to purchase a $100,000 house and the lender only allows an LTV ratio of 80, the maximum you can borrow is $80,000. If your credit is poor, the lender may require a lower LTV—which means you'll have to make a bigger down payment.**

The value part of the equation is determined by **an appraisal**. If the house you are interested in buying appraises for less than the price you agreed to pay, you may have to come up with more cash for the down payment in order to satisfy the LTV ratio (or find a lender with more lenient LTV guidelines).

THE DOWN PAYMENT

Historically, American home buyers put down 20 percent of a purchase price and borrowed the other 80 percent. But the booming real estate values of the 1980s and 1990s required more flexible loans.

In the 2000s, buyers make a down payments of 10 percent, 5 percent, 3 percent—or even zero. But all of these **low-down-payment loan packages** require good credit.

The low-down-payment loans also require **Private Mortgage Insurance (PMI)**, which is an insurance policy that protects the lender in case the borrower defaults on the loan. Borrowers (not the lenders who benefit from PMI) usually pay for the insurance as part of their mortgage payment each month.

One way to get around paying PMI and still avoid paying 20 percent down is to get an 80-10-10 loan. This is a relatively new option that combines an 80 percent mortgage with a 10 percent home equity loan and a 10 percent down payment. An 80-10-10 is useful not just for avoiding PMI; it also is used many times to avoid getting a jumbo loan when you only put 10 percent down.

Whatever the amount you're putting down, potential lenders may want to see the money for the down payment in your bank account or someplace else where it's very liquid before they will fund the loan.

If your credit score is low—in the 500s—lenders may also want to know that you have **sufficient cash reserves** to cover the cost of your mortgage, plus taxes and homeowners insurance, for a number of months. The number of months worth of reserves required will vary from lender to lender and based on your score.

> These reserves are often called PITI reserves. PITI
> stands for principal, interest, taxes and insurance.

CLOSING COSTS

Many first-time home buyers are astonished by the variety and size of the fees that show up on their statement at closing time. You definitely will need to set aside more money than you'll need for the down payment alone.

You also will want to compare fees when shopping for a mortgage. These fees can include:

- an application fee;
- a commitment fee;
- a loan origination fee;
- a loan processing fee;
- an appraisal fee;
- a recording fee; and
- prepaid expenses.

These fees are often lumped together under the term **closing costs**. And they vary according to your credit score. High closing costs are perhaps the worst side-effect of having poor credit. They can add thousands of dollars to the cost of buying a house.

You may be able to **include the closing costs in your loan**. This reduces your out-of-pocket costs up front, but it increases your monthly mortgage payment.

LO-DOC AND NO-DOC LOANS

If you value your privacy, then you'll find the mortgage application process particularly distasteful.

Most mortgage lenders require you to provide full income verification. They'll want copies of your pay stubs, copies of your income tax returns and other documentation before they give you a loan. In exchange for this lack of privacy, you get **the best possible interest rate** for your loan.

Your alternative is to trade in the best rate in favor of some privacy by applying for a low-documentation or no-documentation loan.

Low-doc loans were designed with several groups in mind:

- entrepreneurs; and
- people who cannot or choose not to reveal their income information.

> **If you opt for a low-doc loan, you probably will have to come up with a higher down payment, as well as pay a higher interest rate. Plus, you will need to have a very good credit score.**

No-doc loans require even less information. All you need to provide is:

- your name;

- your address;

- your Social Security number; and

- contact information for your employer, if you have one.

The lender then will pull your credit reports and decide whether to lend you the money based solely on your credit history, the size of your down payment and the value of the home you're buying.

Low- and no-doc loans aren't a way to get around credit ratings. In fact, they usually require *better* credit than standard loans. So, they aren't for people who want to down-play low credit scores.

LENGTH OF THE LOAN

Another factor to consider when you're loan shopping is the **length (or term) of the loan**. With most conventional mortgages, you'll be making payments for either 15 or 30 years.

If you opt for the longer term loan, you will wind up paying more interest. However, you will have lower monthly payments. If your credit score is weak, your loan broker or bank will probably recommend **a longer term with lower payments**.

If you select a 15-year loan, you'll pay less in interest and pay higher monthly payments. Plus, you'll build up equity in the house much faster, since more of your payments will be principal from the start.

You also should be able to get a lower interest rate for a shorter-term loan. But your lender will probably want to see at least a good credit score (in the mid-600s) to approve this kind of loan.

REFINANCING

If you're planning to stay in your home a while, there are many good reasons to consider refinancing. These include:

- getting a lower interest rate;
- cashing out some of the equity in your home; and
- changing the loan term.

Through the 1990s and early 2000s, many American homeowners refinanced their properties—sometimes more than once—as interest rates dropped to record lows. Doing so, they were able to lower their monthly payment—often dramatically.

Because real estate prices also had climbed dramatically in many areas, some of these homeowners also took the opportunity to "cash out" some of their equity. In other words, when they refinanced, they got a new loan for a higher amount than they owed on the old loan. They received the difference in cash. In many cases, they used this cash to pay off credit cards and other forms of non-secured consumer debt that carried high interest rates.

Still other homeowners found that they were in better financial shape than they had been when they got their initial loan. So, they chose to refi from a 30-year loan to a 15-year loan. This way, they reap the benefits of an even lower interest rate and they accumulate equity in their home faster.

A refi can be good for people whose credit scores have improved during the time that they've owned their home. (And this happens fairly often, when people settle down from less responsible young-adult years.) If you paid high closing costs to get a high interest-rate mortgage when you bought your house, keep an eye on your credit score. If it's risen 50 points or more, you may be able to get a better loan on better terms.

AUTO LOANS

Some people assume that they have to get financing at the dealership where they purchase their car or truck. **This is wrong**.

Getting the loan through the dealership can be more convenient, particularly if you're car shopping in the evening or on a weekend, when the banks are closed. But it's **the most expensive way to go**.

The fact that most automakers have their own finance division, such as Nissan Motor Acceptance Corp. and Ford Credit, gives you an idea of just how lucrative the auto loan business can be.

You should analyze your finances and figure out just how much of a monthly payment you can afford—before you fall in love with a car that's outside your price range.

> The credit requirements for borrowing to buy a car are usually not as stringent as for borrowing to buy a house. As long as your score is above 500, you should be able to get some form of new car loan. But—as with mortgages—the lower your score, the more cash you'll have to put down and the more interest rates you'll have to pay. These factors (particularly the down payment) are what take some people out of the new car market.

Another factor that most people don't consider is the true cost of car ownership. This includes:

- maintenance costs;
- depreciation (which can vary dramatically by model and manufacturer);
- interest on your loan;
- taxes and fees;
- insurance premiums (which also vary dramatically from vehicle to vehicle);
- fuel costs; and
- repairs.

Several Internet Web sites have tools that will help you determine the **true cost of ownership** for a vehicle, including www.edmunds.com.

SHOPPING FOR CAR LOANS

The *best* strategy is to drive the best car—new or used—that you can afford to **buy for cash**.

Simply said, paying interest to buy a depreciating asset means you're losing money two ways: in the interest and in the lost asset value. You should borrow as little as possible for the shortest period of time you can afford.

But most people need to finance their car purchases—the things just cost too much. So, keep in mind that the best approach to financing a car purchase is different than financing real estate:

- When you're buying a house, the best strategy is usually to borrow as much money as you can afford to buy the most house you can. This means making the *smallest* down payment that you can.

- When you're buying a car, the best strategy is usually to borrow as little as you have to in order to get least-expensive car that fits your needs. This, effectively, means making the *largest* down payment you can.

While you can get a loan for a vehicle through the dealership that sells it, you should compare the interest rates and terms available through **banks, online lenders and credit unions**, too.

> But don't mention financing when you're negotiating the price of a vehicle. Keep the initial talks focused solely on the total cost of the car or truck. (Likewise, mention trade-ins later—after you've finished negotiating the vehicle's purchase price.)

The biggest decision, when you're shopping for an auto loan, is the **length of the loan**. Most auto loans today require from 36 to 60 months worth of payments. In other words, they're three-, four- or five-year loans. (You'll also find some two- and six-year loans; but they are less common.)

Just as with a home loan, the longer the term of an auto loan, the lower your monthly payment—but the higher the total amount of interest you'll have to pay.

If you have a tendency to trade-in or sell your cars every two or three years, you should rethink your priorities. But, if driving a new car so often is important to you, avoid the longer-term loans and their low payments. You may **owe more than your vehicle is worth** if you try to sell it after two years and you have a five- or six-year loan.

> Interest rates are usually higher on used vehicle loans than on loans for new vehicles. This and other factors actually can make it cheaper for you to finance a new vehicle. An exception: so-called "certified, pre-owned" programs which sell high-quality used cars on terms very close to those of new cars.

When you're comparison shopping for your loan, you also may want to have it quoted with several **different down payments**. A higher down payment will reduce your monthly payments, and it also may reduce the interest rate on your loan.

However, you may find that the difference in monthly payments between a $1,500 down payment and a $3,000 down payment is insignificant over the course of a five-year loan, in which case it probably pays to hold onto your money for now.

CONCLUSION

The markets for financing homes and cars are large enough that there's room for just about anyone. But your credit score will determine how much cash you need to put down to buy a home or car...and how much interest you pay for a loan.

These numbers effectively push people with poor credit out of the marketplace. And they give real advantages to people with good credit.

A person with a FICO score of 750 can pay $500 less a month for a $300,000 mortgage than someone with a score of 570 pays. And those savings are a sort of **perpetual advantage** that helps the higher scores stay higher.

But remember this: While you're making payments on a home or car, most people will consider you the owner. You're not. The lender owns your home or your car until you've paid it off in full. Then you receive the clear title and *really* own it.

CHAPTER **13**

KEEPING GOOD
CREDIT

Once you've checked your credit score and done all you can to raise it to a comfortable level, keeping it there should be relatively easy.

Remember basic guidelines:

- keep a monthly budget, no matter much money you have;

- don't use credit cards to make impulse purchases;

- avoiding manic highs and lows of spending/saving (scoring systems reward steady performance);

- don't borrow to buy depreciating assets.

But these guidelines don't address some more basic questions. Like "What's a **safe amount of consumer debt** to carry?" And this is a good question to ask because, with all the various payments an ordinary American makes each month, it's easy to lose track of just how much you owe.

> To answer the question of how much debt you can handle, use the 20/10 Rule: *Never borrow more than 20 percent of your annual net income (after taxes) on credit card. And your monthly payments should never exceed 10 percent of your monthly net income.*

EVERGREEN ADVICE

Keep track of every credit purchase you make each month. This will help establish your monthly credit "budget" and spare you eyebrow-raising surprises when your bill comes.

Plan your credit spending. Use your credit for planned purchases that you intend to pay off over a specific time period. Impulse buys for "unbeatable" prices can stay on your bill for months, costing you more in the long run.

Before taking cash advances, consider the associated **fees and finance charges**. They can be much higher than the interest on purchases.

Avoid approaching or **reaching your credit limit** if at all possible. You'll save on finance charges and keep credit available for emergencies like car repairs or unplanned medical costs.

And keep an eye out for these warning signs:

- You're only able to make the minimum payment on your credit cards for two months in a row.

- You've taken more than one cash advance (outside of travelling) in the last 90 days.

- You're surprised by the number of new purchases on any of your credit cards.

- You've done more than one balance transfer in the last six months.

- You reached or exceeded the limit on any credit card in the last three months.

- You need to work overtime or a second job to keep up with your consumer debt payments.

- You've made more than one late payment to a credit card or secured loan account in the last 12 months.

As we've noted, no one of these problems will hurt your credit score dramatically. But several of them happening at the same time can do real damage.

MANAGING CREDIT

With a strong credit score, you will receive a steady stream of offers for credit cards, car loans and home mortgages. Some people work hard to have their names removed from any such mailing lists.

But these mailings can be useful to you, since they show you what the state of marketplace is for consumer credit deals.

Plus, occasionally, you may see an offer **that's really better than anything you have**.

If you decide to get a new credit card, make sure the terms are genuine—and **permanent, not "promotional"**—and that the offer is really better than the cards you have.

Try to keep no more than four active credit card accounts. If you find a really good offer, replace a card that costs you more. And **take your time** doing so.

> In most cases, you shouldn't close out your oldest card. It has the most history and adds stability to your score. Generally, it's good to have had your credit card accounts for an average of at least three years.

Slowly close out unneeded or unused credit accounts. And, be cautious when canceling—because closing accounts can negatively impact your credit score.

Even if creditors offer to raise credit limits, allow yourself only moderate credit limits.

WATCH THE BALANCE TRANSFERS

Moving a card balance from a higher interest rate card to a lower interest rate one can make sense and save you money. But move carefully on these deals—and, in any case, don't do them more than once or twice a year.

> **Remember: Transferring a balance is not the same thing as paying off a debt. The best way to free up more cash for the long haul is to eliminate credit card debt. You'll need to continue to pay as much as you can on those credit cards.**

Watch the fees. Some companies charge a "transaction fee" for the privilege of transferring a balance to their card.

When you transfer a balance, make sure that you continue to make minimum payments on your old card while waiting for a balance transfer to take effect, which can take several weeks.

Some balance transfer offers include fine print that says the company may **check your credit score** before offering you the low rate. If your score is too low (and it may still be pretty good, generally) the company may charge you a higher-than-advertised rate. Even though the offer might say 1.9 percent rate on balance transfers, you may qualify for a 10.99 percent rate.

The February 2000 New York state court decision *Gerald Broder v. MBNA Corp., et al.* considered charges of just such a rate-switching trick.

Broder had carried an MBNA MasterCard since 1987. He regularly used it to pay for purchases, generally paying off his purchase balances in full each month, without incurring any finance charges.

In October 1996, MBNA offered Broder a deal to take cash advances, subject to a special low annual percentage rate of 6.9 percent, for up to six months—through May 1997. At the end of the six-month period, the outstanding cash advance balance would be subject to the same 17.9 percent APR as Broder's other outstanding unpaid purchase balance. The special offer brochure stated:

> *Your Annual Percentage Rate (APR) on cash advances, including balance transfers is 6.9% through your statement closing date in May 1997.*

> *This means you can use the full power of your... MBNA MasterCard account along with this special low 6.9% Annual Percentage rate (APR) to reduce your cost of credit or even take advantage of sales and bargains And with your low limited-time APR of 6.9% on cash advances, including balance transfers, you may be able to save yourself some money (not to mention headaches) by simply paying off higher rate credit card or department store accounts....*

Notice the use of the term "paying off." Transferring a debt balance from one card to another isn't "paying off" anything. It's just changing the name of the lender you owe.

Broder accepted MBNA's offer in November 1996 and made a balance transfer cash advance of $25,000 from another credit card. He was supposed to get the promotional rate of 6.9 percent on this amount.

(At the time of the transfer, he didn't have any outstanding unpaid balance on the MasterCard.)

In December 1997, MBNA made another cash advance offer to Broder. This time, the deal was a special low APR of 6.9 percent for up to six months—through June 1998. At the end of the six-month period, the outstanding cash advance balance would again jump to 17.9 percent.

This time the brochure stated:

> *Introducing your new 6.9% Annual percentage rate (APR) through your June 1998 statement closing date on Credit Card Access Checks and Balance Transfers.*
>
> *MBNA is pleased to announce an APR so low you don't even have to think twice about taking full advantage of your credit line. This is just about as inexpensive as it gets to use somebody else's money.*
>
> *And, better, because this rate is so good, MBNA is giving you all the way through the closing date of your June 1998 statement to take advantage of it.... We really hope you start taking advantage of your special MBNA APR in January and keep taking advantage of it through your June 1998 statement closing date.*

In January 1998, Broder again took MBNA's offer and obtained a balance transfer cash advance of $35,000 at the special rate.

After receiving the $25,000 and $35,000 cash advances, Broder continued to use MBNA's card for purchases, generally in amounts totaling $500 to

$2,200 each month. Each month during the promotion's operative period, the payments to his account generally equaled the total new purchases shown on his monthly account statements.

But MBNA **applied his payments first to the balance due on the advances** made under the special promotion (which was a lot larger than the amounts of his total new monthly purchases).

TRICKY ACCOUNTING

Under the method of payment allocation used by MBNA, Broder's cash advances subject to the 6.9 percent rate were reduced by the amount of his monthly payments while his purchase balances remained wholly unpaid and continued to accrue finance charges at the higher rate.

As a result, Broder was charged finance charges by MBNA on his purchase balance during the six-month limited period covered by the $25,000 cash advance totaling $767—even though his payments each month were **enough to pay off the purchases in full.** Broder argued that finance charges should have been only $313 on the balance transfer amount. So, he claimed MBNA had charged him $450 more than it should have.

He claimed that MBNA had used the same tricky accounting to overcharge him about $200 on the $35,000.

When Broder couldn't get any satisfaction from MBNA directly, he sued. (Unfortunately, for MBNA, Broder was an attorney who specialized in class action lawsuits.) His lawsuit contained three charges: **breach of contract, fraud** and violation of New York business law barring **deceptive practices and false advertising**. He also asked the court to certify his lawsuit as a class action, open to any MBNA cardholders who accepted the special balance transfer offers.

MBNA fought aggressively, asking the court to throw out Broder's whole case. It argued that it didn't breach the agreement with plaintiff and that the advertisements were neither false nor misleading. MBNA pointed to its cardholder agreement that stated payments "will be allocated in a manner we determine" and language in the solicitation materials stating that it could allocate payments first to the cash advance balance and than to the purchase balance.

The court agreed that MBNA didn't breach the literal terms of its contract with Broder. But, it ruled that Broder had made viable claim for breach of the implied covenant of good faith.

The court looked at the brochures that MBNA had used and concluded:

> ...there are issues of fact resulting from ambiguous language contained in the cardmember agreement and the solicitation. Ambiguities are construed against the drafters of the relevant materials.

THE LAW ON FINE PRINT

Perhaps the most interesting conclusion the court made about Broder's charges involved a literal discussion of the term *small print*. Some of MBNA's contract language about how it would allocate payments was—literally—in small print. And New York had a law about jamming **weasel words in tiny type**. The court cited state law which said:

Contracts in small print

The portion of any printed contract or agreement involving a consumer transaction ...where the print is not clear and legible or is less than eight points in depth or five and one-half points in depth for upper case type may not be received in evidence in any trial, hearing or proceeding on behalf of the party who printed or prepared such contract or agreement, or who caused said agreement or contract to be printed or prepared. ...No provision of any contract or agreement waiving the provisions of this section shall be effective.

Although the statute referred to evidence admissibility in trials, its purpose was to make such contract provisions unenforceable. The relevant language about payment allocation contained in the MBNA's solicitations was smaller than the required eight-point type.

The court also allowed the deceptive practices claim to go forward; but it did throw out the fraud charge essentially for being redundant to the others.

And the court certified Broder's lawsuit for class action status. Anyone who'd taken a cash advance

or transferred a balance from MBNA during the same period could join him. The ruling was a substantial loss for MBNA, which promptly began negotiating a settlement with Broder.

GUARD AGAINST ID THEFT

Your credit card provides you with valuable purchasing power and convenience. To purchase a number of goods and services, all you need to do is present your card and sign a receipt. Unfortunately, this power and convenience also make your card that much more appealing to criminals looking to take advantage of your credit.

Guard your credit cards as you would the key to your home. When receiving a new or replacement card, sign the back immediately. Keep it and any duplicate cards in a secure place where you would know if they were missing.

Never leave your card with someone as a "security deposit." And, if you're expecting a new or replacement card, keep a sharp eye on the mail.

Since a thief can just as easily make purchases with only your account number and expiration date, it's a good idea to take all receipts and carbons with you, especially from places like automated teller machines (ATMs), supermarkets, and self-service gasoline pumps.

Avoid disposing of purchase documents or old statements in public trash containers, and never give your account number to someone **calling you on the phone**—even if the caller says it will be used to claim a "valuable" prize or award.

Your personal information should always stay with you. With the exception of mail order companies, merchants should never require your address or telephone number to complete a transaction.

Avoid using a credit card as personal identification. Never let someone put your card number on a check or any other document not associated with a purchase on your account. (In some states, it is actually against the law for merchants to do so.) Use your driver's license or other ID instead.

If your account has a personal identification number (PIN) for use at ATM locations, don't write it down: memorize it. And it's a good idea not to pick an obvious PIN, like your address, phone number, or date of birth.

LOST OR STOLEN CARDS

If a card is used before you report it lost or stolen, your maximum liability for unauthorized charges is $50 per card. If you report your card stolen before someone uses it, your liability may be zero.

But, if a member of your immediate family (spouse, child, parent) borrows your credit card to make a purchase—with or without your knowledge—you may be liable for that purchase.

> **Notify your card issuer if you and your spouse become separated or divorced. Otherwise, you could be liable for charges on your joint account.**

REVIEW YOUR STATEMENTS

Billing errors can happen. So it's important to save your receipts and credit slips and compare them to your monthly statements. File your statements in a secure place for future reference.

If you choose not to keep your statements, destroy them before throwing them away.

If you do discover an error on your statement (like an unauthorized charge or purchase), write to your card issuer immediately. Be sure to state that it is a **billing error**, which is handled differently than a dispute with a merchant.

> **Remember: You must notify your card issuer in writing to be legally protected. Also, it is far more difficult to challenge a charge once it has been paid.**

ON-LINE SAFETY

Although the numbers are increasing, consumers are still not using their credit cards on the Internet nearly as much as electronic retailers would like. That's why many on-line merchants continue to offer a toll-free order number so that shoppers have the choice of calling their order in.

> On-line shopping may be convenient—some people do all of their shopping on-line—but credit card fraud is always a threat. Hackers have found ways to steal credit-card numbers from Web sites.

While Internet companies have taken responsibility for security breaches and resulting losses to credit card users, there remains the growing problem of people who use stolen credit cards to make purchases on the Internet. And, while unfair or fraudulent practices by credit card companies are not commonplace, they do happen.

Fortunately, the Federal Trade Commission and the media are watching. In 1994, the FTC ordered TransUnion to stop selling "sensitive" consumer data—data on 160 million Americans—to junk-mail producers. The FTC charged that TransUnion violated the Fair Credit Reporting Act by **selling consumer information** to target marketers who lack any of the allowable purposes listed under the act. TransUnion denied that it had sold information that could affect customers and appealed the FTC's rul-

ing. But it lost.

If the mailing list issue bothers you, pay close attention when you're completing any credit-card application. Most application forms provide a box that you can check to allow or disallow the selling of your information to mailing lists—but some remain hazy about how they will use your name and information.

> You can also protect yourself by contacting the three main U.S. credit bureaus and instructing them to take your name off of their mailing lists. When you write to the bureaus, include your complete name, name variations and mailing address, Social Security number and signature—and state clearly that you want your name removed from marketing lists.

OTHER TIPS

These tips are important and universal:

- **Sign your card**—as soon as you receive it. (Obviously, this is only as effective as the clerk who's checking it.)

- When you use your card at an ATM, enter your PIN in such a way that no one can easily memorize your keystrokes.

- **Don't leave your receipt** behind at the ATM. Your PIN and account number

from a discarded receipt could make you vulnerable to credit card fraud.

- Don't give your credit card number over the telephone **unless you initiated the call**.

- Make certain you get your card back after you make a purchase (one way to dot his: **leave your wallet open in your hand** until you have the card back). Also, make sure that you personally rip up any voided or cancelled sales slips.

- **Keep a list** of your credit cards, credit-card numbers and relevant toll-free numbers in a safe place, in case your cards are stolen or lost.

CONCLUSION

Really, maintaining a good credit score is a matter of **lots of small steps** to keep your spending—and the bad guys out in the world—in check. But the results of these small steps can mean tens of thousands of dollars in interest and finance fees that you get to keep.

It's the best example of how important it is to keep track of the little things.

KEY CREDIT TERMS

1/1 **ARM**: an adjustable-rate mortgage that has an initial interest rate for the first year, and thereafter has an adjustment interval of one year. Each annual rate adjustment is based on (or "indexed to") another rate-often the yield on a U.S. Treasury note

10/1 **ARM**: an adjustable-rate mortgage that has an initial interest rate for the first 10 years, and thereafter has an adjustment interval of one year

3/1 **interest-only ARM**: an adjustable rate mortgage in which none of the payments go toward retiring principal for the first three years

80-10-10 loan: a combination of an 80 percent loan-to-value first mortgage, a 10 percent home equity loan and a 10 percent down payment. The loans can be used to eliminate the need for private mortgage insurance

adjustable-rate mortgage (ARM): a home loan in which the interest rate is changed periodically based on a standard financial index. Most ARMs have caps on how much the interest rate can rise or fall

alternative mortgage: a home loan that is not a standard fixed-rate mortgage

annual fee: a flat fee charged each year for your credit card account, similar to a membership fee

annual percentage rate (APR): the interest rate being charged, expressed as a yearly rate. Credit card accounts often have several different APRs— one for purchases, one for cash advances and one for balance transfers. Some lenders may increase the APR if a payment is late

application fee: amount the lender charges to process the document in which a prospective borrower details his or her financial situation to qualify for a loan. Quality lenders do not charge these fees (though they may charge many others)

application scoring: the use of a statistical model to evaluate credit applications and credit bureau data in order to assess likely future performance. Scores help businesses make decisions such as whether to accept or decline the application

appraisal fee: amount someone charges to deliver a professional opinion about how much a property is worth

appraised value: an educated opinion of how much a property is worth

authorized user: anyone who uses your credit cards or credit accounts with permission; more specifically, someone who has a credit card from your account with his or her name on it

back-end ratio (or back ratio): the sum of your mortgage payment and all other monthly debt/credit cards, car payments, student loans, etc., divided by before-tax income. Traditionally, lenders wouldn't extend borrowers' back-end ratios past 36 percent, but they often do now

balance transfer: moving all or part of the outstanding balance on one credit card to another

balloon loan: a loan in which the payments don't repay the principal in full by the end of the term. At the end comes the balloon payment—one that's larger than the others and pays off the principal

bankruptcy: a proceeding (in the U.S., in federal court) that may legally release a person from repaying debts owed. Credit reports normally include bankruptcies for up to 10 years

biweekly mortgage: a mortgage that schedules payments every two weeks instead of the standard monthly payment. The 26 biweekly payments are each equal to one-half of a monthly payment. The result is that the mortgage is paid off sooner

broker premium: a sum paid to a mortgage broker as the "middleman" in the process between the lender and the borrower

cardholder: the person in whose name a credit is issued and/or any authorized user

cash-advance fee: a fee charged if you obtain a cash advance. This fee is in addition to the interest rate charged on the amount of the advance

cash-out refinance: a new mortgage on an existing property in which the amount borrowed is greater than the amount of the previous mortgage. The difference is given to the borrower in cash

charge-off: the balance on a credit obligation that a lender no longer expects to be repaid and writes off as a bad debt

closing costs: expenses incurred when transferring ownership of or borrowing against a property—including lender, title and escrow fees

collateral: an asset or property used as security against a loan

collection: attempted recovery of a past-due credit obligation by a collection department or agency

combined loan-to-value ratio: an overall mortgage debt load, expressed as a percentage of the home's fair market value. Someone with a $50,000 first mortgage and a $20,000 equity line secured against a $100,000 house would have a CLTV ratio of 70t

commitment fee: a sum paid by a borrower to a lender in exchange for a promise to lend money on certain terms for a specified period. Quality lenders tend not to charge these fees

conforming loan: a mortgage that meets the requirements to be eligible for purchase or securitization by one of the government-sponsored enterprises (such as Fannie Mae and Freddie Mac). Requirements include size of the loan, type and age

consumer credit file: a credit bureau record on a given individual. It may include information on one credit account...or many

convertible ARM: an adjustable rate mortgage that can be converted to a fixed-rate mortgage under specified conditions

credit bureau: a credit reporting agency that is a clearinghouse for information on the credit rating of individuals or firms. The three largest credit bureaus in the U.S. are Equifax, Experian and TransUnion

credit history: a record of how a consumer has repaid credit obligations in the past

credit limit: the most that can be charged on a credit card or to a credit line

credit obligation: an agreement by which a person is legally bound to pay back borrowed money or used credit

credit report: complete information communicated by a credit reporting agency that bears on a consumer's credit standing. Most credit reports include: consumer name, address, credit history, inquiries, collection records, and public records such as bankruptcy filings and tax liens

credit score: another term for a credit bureau risk score. Generally, it refers to a number generated by a statistical model which is used to objectively evaluate information that pertains to making a credit decision

debt-to-available-credit ratio: the amount of money a person has in outstanding debt, compared to the amount of credit available on all of the individual's credit cards and credit lines. The higher a person's debt to available credit, the more risky the individual appears to potential lenders

debt-to-income ratio: the percentage of before-tax earnings that are spent to pay off loans for obligations such as auto loans, student loans and credit card balances. Lenders look at two ratios. The *front-end ratio* is the percentage of monthly before-tax earnings that are spent on house payments. In the *back-end ratio*, the borrower's other debts are factored in

default: a designation on a credit report that indicates a person has not paid a debt that was owed. Accounts usually are listed as being in default after several reports of delinquency. Defaults are a serious negative item on a credit report

delinquency: a failure to deliver even the minimum payment on a loan or debt payment on or before the time agreed. Accounts are often referred to as 30, 60, 90 or 120 days delinquent because most lenders have monthly payment cycles

Equal Credit Opportunity Act (ECOA): U.S. federal legislation that prohibits certain kinds of discrimination in credit transactions

equity: the portion of the appraised value of an asset that is greater than the total of the secured financing attached to that asset. Also called the lendable value or net value

Fair Credit Reporting Act (FCRA): U.S. federal legislation that promotes accuracy, confidentiality and proper use of information in the files of a consumer reporting agency

Fannie Mae: the largest mortgage investor, a government-sponsored enterprise that buys mortgages from lenders, bundles them into investments and sells them on the secondary mortgage market. Formerly known as the Federal National Mortgage Association

Federal Housing Administration (FHA): an agency within the federal Department of Housing and Urban Development that provides mortgage insurance and sets construction and underwriting standards

FICO score: a credit bureau risk score produced from any of several models developed by Fair, Isaac & Co. FICO scores are used by lenders and others to assess the credit risk of prospective borrowers or existing customers

finance charge: the dollar amount you pay to use credit. Besides interest costs, the finance charge may include other charges such as cash-advance fees

first mortgage: the primary loan on a property, which has priority over all other claims to the title

fixed rate: an annual percentage rate for a finance charge that does not change with other indexes

fixed-rate option: an option available on some home equity lines of credit which allows borrowers to fix the interest on a portion of their balance

foreclosure: the legal process by which a debtor in default on a mortgage or other loan is deprived of interest in the collateral property. This usually involves a forced sale of the property with the proceeds of the sale being applied to the mortgage debt

Freddie Mac: formerly known as the Federal Home Loan Mortgage Corp., this is a government-sponsored firm that buys mortgages from lenders, pools them with other loans and sells them to investors

front-end ratio (or "front ratio"): the percentage of monthly before-tax income that goes toward a house payment. The rule of thumb is that the front ratio shouldn't exceed 28

Ginnie Mae: also known as the Government National Mortgage Association, a part of the federal Department of Housing and Urban Development that guarantees securities backed by mortgages that are insured or guaranteed by other government agencies

grace period: a period of time, often about 25 days, during which you can pay your credit card bill without incurring a finance charge. Under nearly all credit card accounts, the grace period applies only if you pay your balance in full each month. It does not apply if you carry a balance forward. Also, the grace period usually does not apply to cash advances

hard inquiry: a request by a lender to see your credit report that must be included in the inquiries section of that report; hard inquiries are triggered whenever you fill out an application for credit, an application to rent an apartment and so on

high-LTV equity loan: a home loan that creates a total loan-to-value ratio of up to 125 percent or more. When the total principal of a loan leaves the homeowner with debt that exceeds the fair market value of the home, the interest paid on the portion of the loan above that value may not be tax deductible

home equity line of credit: an open-ended loan, paid as revolving debt, that is backed by the portion of a home's value that the borrower owns outright

home equity: the part of a home's value that the mortgage borrower owns outright; the difference between the fair market value of the home and the principal balances of all mortgage loans

Home Ownership and Equity Protection Act: a U.S. federal law designed to discourage predatory lending in mortgages and home equity loans

housing expense ratio: the percentage of monthly before-tax income that goes toward a house payment. The rule of thumb is that it shouldn't exceed 28 (also known as the "front ratio")

income verification: a requirement for fully documented proof of income on the part of a borrower; loans of this type usually offer lower interest rates than no-income or "no-doc" verification loans.

inquiry: an item on a consumer's credit report that shows that someone with a "permissible purpose" (under FCRA rules) has previously requested a copy of the consumer's report

installment account: a loan for which the borrower makes the same payment each month

interest rate cap: a limit on how much a borrower's percentage rate can increase or decrease at rate adjustment periods and over the life of the loan

interest rate: a measure of the cost of credit, expressed as a percent. For variable-rate credit card plans, the interest rate is explicitly tied to another interest rate. The interest rate on fixed-rate credit card plans, though not explicitly tied to changes in other interest rates, can also change over time

interest: money paid for a borrower's use of money, calculated as a percentage of the money borrowed and paid over a specified time; also, a right to, or share of, title to collateral property

interest-only loan: an advance of money in which the repayment installments cover only the interest that accumulates on the loan balance. The principal does not decrease with the payments. Usually, interest-only loans have a short term

introductory rate: a temporary, lower APR that usually lasts for about six months before converting to the normal fixed or variable rate

judgment: a decision from a judge on a civil action or lawsuit; usually an amount of money a person is required to pay to satisfy a debt or as a penalty

late payment (a "late"): a delinquent payment or failure to deliver a loan or debt payment on or before the time agreed

late-payment charge: a charge imposed when your payment is late. If your payment arrives after the grace period, you may be charged both a finance charge (the interest on your outstanding balance) and a late-payment charge

lien (pronounced "lean"): a legal claim placed on a person's property, such as a car or a house, as security for a debt. A lien may be placed by a contractor who did work on your house or a mechanic who repaired your car and didn't get paid. The property cannot be sold without paying the lien

loan origination fee: a charge levied by a lender for underwriting a loan. The fee often is expressed in "points;" a point is 1 percent of the loan amount

loan processing fee: a charge levied by a lender for accepting a loan application and gathering the supporting paperwork

loan-to-value ratio (LTV): the percentage of the home's price that is financed. On a $100,000 house, if the buyer makes a $20,000 down payment and borrows $80,000, the loan-to-value ratio is 80. When refinancing a mortgage, the LTV ratio is computed using the appraised value of the home, not the sale price

low-documentation loan: a mortgage that requires less verification of income or assets (or both) than a conventional loan. Low-documentation loans are designed for the entrepreneur or self-employed—or for borrowers who cannot or choose not to reveal information about their incomes

low-down mortgages: secured loans that require a low down payment, usually less than 10 percent. Fannie Mae and Freddie Mac design loan programs that spell out a set of standards for lenders

mortgage banker: a person or firm that originates home loans, sells them to investors, services monthly payments and handles escrow. Some mortgage bankers sell their loans on the secondary market

maxed out: a slang phrase for using the full credit limit of a credit card or the full amount available on a line of credit. Borrowing the maximum limit on cards or equity lines hurts your credit score

mortgage broker: a person or firm that finds lenders for prospective borrowers who meet the lenders' criteria. A mortgage broker does not make the loan, but receives payment for services

mortgage interest expense: a tax term for interest paid on a loan that is fully deductible, up to certain limits, when you itemize income taxes

mortgage refinance: a refinanced mortgage is one in which a borrower pays off an old loan with a new loan. People who refinance a mortgage usually do so to get a lower interest rate, lower their payments or to take cash out of their equity.

no-documentation loan: a mortgage in which the applicant provides a minimum of information—name, address and Social Security number. The underwriter decides on the loan based only on the applicant's credit history, the appraised value of the house and size of down payment

over-limit fee: A fee imposed when your charges exceed the credit limit set on your card

penalty rate: a higher interest rate applied to your credit card account if you are late making payments

periodic rate: the interest rate you are charged each billing period. For most credit card plans, the periodic rate is a monthly rate, calculated by dividing the APR by 12. A credit card with an 18 percent APR has a monthly periodic rate of 1.5 percent

PITI: acronym for the elements of a mortgage payment: principal, interest, taxes and insurance

point: a unit more measuring fees related to a loan; a point equals 1 percent of a mortgage loan. Some lenders charge "origination points" to cover expenses of making a loan. Some borrowers pay "discount points" to reduce the loan's interest rate

pre-approval letter: a document from a lender or broker, estimating how much a potential home-buyer could borrow, based on current interest rates and a preliminary look at credit history

prepayment penalty: lender's charge to the borrower for paying off a loan before the end of its scheduled term

pre-qualification letter: a non-binding evaluation of a prospective borrower's finances to determine how much he or she can borrow and on what terms

principal: the amount of money borrowed in a loan or the amount of money owed, excluding interest

private mortgage insurance (PMI): a form of insurance that protects the lender by paying the costs of foreclosing on a house if the borrower stops paying the loan. Private mortgage insurance usually is required if the down payment is less than 20 percent of the sale price

public records: information that is available to any member of the public, typically by visiting the local courthouse; public records like a bankruptcy, tax lien, foreclosure, court judgment or overdue child support often appears on your credit report

qualifying ratios: as calculated by lenders, the percentage of income that is spent on housing debt and combined household debt

rate shopping: applying for credit with several lenders to find the best interest rate, usually for a mortgage or a car loan. If done within a short period of time, such as two weeks, it should have little impact on a person's credit score

reaffirmation agreement: an agreement by a bankrupt debtor to continue paying a dischargeable debt after the bankruptcy, usually to keep collateral or mortgaged property that would otherwise be subject to repossession

repayment period: in a home equity line of credit, that portion of the life of the loan that follows the draw period. During the repayment period, the borrower cannot take out any more money, but must pay down the loan

revolving account: an account on which your balance and monthly payment can fluctuate, and which you can "spend up" and "pay down" repeatedly, such as a Visa or a gasoline credit card

risk score: a type of credit score based solely on data stored at the major credit bureaus. It offers a snapshot of a consumer's credit risk at a particular point in time

Schumer box: a graphic display, required by the U.S. Truth in Lending Act, that explains the terms and conditions of a consumer credit account. It must appear on credit applications and usually appears on statements and other documents

scoring model: a statistical formula that is used, usually with the help of computers, to estimate future performance of prospective borrowers and existing customers. A model calculates scores based on data such as a consumer's credit report

second mortgage: a loan using a home's equity as collateral and which is subordinate to the original mortgage (in a sale, the first mortgage is repaid first)

secured credit card: a consumer credit account for which the borrower must produce some form of collateral—usually a cash deposit equal to the amount of the credit card charge limit

secured debt: a loan on which a piece of property, such as a house, is used as collateral; the collateral provides security for the lender, since the property can be seized and sold if you don't repay the debt

signature loan: a high-interest, unsecured consumer loan based soley on the borrower's credit score; like a cash advance, without the credit card

soft inquiry: a request to see your credit report-or get information about your creditworthiness that was not triggered by your application to get credit; it must appear on your credit report in the inquiries section. Soft inquiries include your request to see your own credit report and job-related requests

subprime borrower: a borrower with a less-than-perfect credit report due to late payments or a default on debt payments. Lenders often grade them based on the severity of past credit problems, with categories ranging from "A-" to "D" or lower

trade line: an account listed on a credit report. Each separate account is a different trade line

unsecured debt: a loan on which there is no collateral, such as a credit card account

utilization ratio: the ratio between the limits on your credit cards or lines of credit and the outstanding balances on those accounts

variable rate: a type of adjustable rate tied directly to the movement of some other economic index. For example, a variable rate might be prime rate plus 3 percent; it adjusts as the prime rate does

INDEX